IMAGES
of Sports

SYRACUSE UNIVERSITY
FOOTBALL

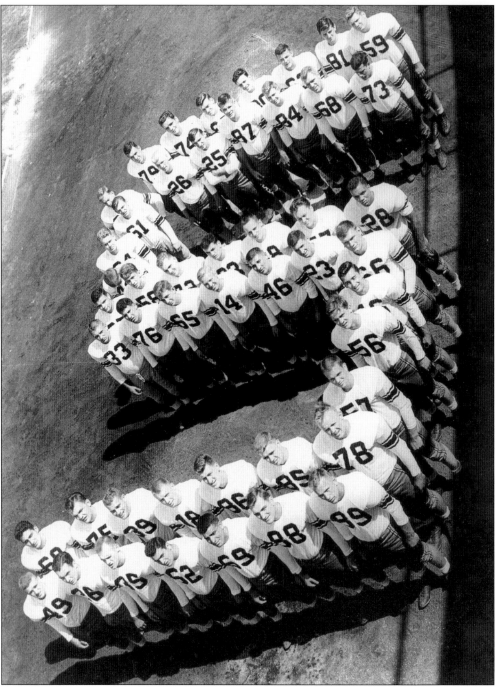

GIVE ME AN S. A Syracuse football team from the early 1950s forms the letter S during a preseason photo shoot.

IMAGES of Sports

SYRACUSE UNIVERSITY FOOTBALL

Scott Pitoniak

ARCADIA

Copyright © 2003 by Scott Pitoniak.
ISBN 0-7385-1200-1

First printed in 2003.

Published by Arcadia Publishing,
an imprint of Tempus Publishing Inc.
2A Cumberland Street
Charleston, SC 29401

Printed in Great Britain.

Library of Congress Catalog Card Number: 2003103002

For all general information, contact Arcadia Publishing:
Telephone 843-853-2070
Fax 843-853-0044
E-mail sales@arcadiapublishing.com

For customer service and orders:
Toll-free 1-888-313-2665

Visit us on the Internet at www.arcadiapublishing.com.

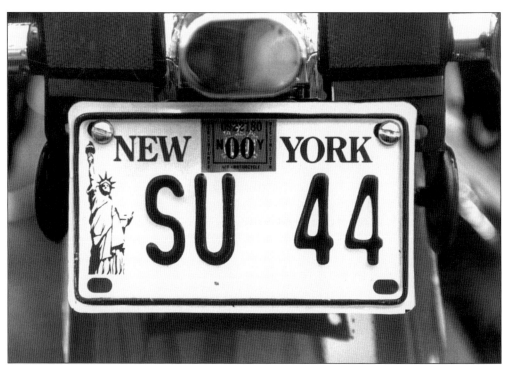

LUCKY NUMBER. Worn by running backs Jim Brown, Ernie Davis, and Floyd Little during their All-American careers with the Orangemen, No. 44 is the most famous number in Syracuse sports history. It is so famous that it is part of the school's postal zip code and telephone exchange.

Contents

Acknowledgments 6

Introduction 7

1. First and Ten: Football Catches On at Syracuse 9

2. A Pigskin Palace Called Archbold Stadium 15

3. Ol' Ben Comes to the Rescue 33

4. Transition Time 71

5. Delirium beneath the Dome 79

ACKNOWLEDGMENTS

A doff of the helmet goes to the teammates who helped make this book possible. They include Tiffany Howe, Amy Sutton, Will Willoughby, and the others at Arcadia Publishing for running with this idea; the Syracuse University (SU) sports information department, especially Sue Edson, Pete Moore, Marlene Ouderkirk, Michele Kelley, and Brian Gunning, for helping me find the photographs that brought this book to life while graciously tolerating my presence and my computer illiteracy; Mary O'Brien, Ed Galvin, and the rest of the archives department at SU's Bird Library; licensing administrator Maureen Riedel and attorney Robert Sinnema for their help with the paperwork; the editors and publishers at the various newspapers I've worked at, for allowing me to chronicle Syracuse football for more than a quarter of a century; Larry Kimball, the school's former sports information director and a kindhearted guy; the players and coaches who have made visits to the Carrier Dome entertaining and memorable; Carl Eilenberg, a longtime friend who has been the enthusiastic "Voice of the Dome" since the joint opened back in 1980; and Ed Shaw, my Syracuse classmate and dear friend who spent many a cold afternoon with me watching some very bad football teams at old Archbold Stadium.

On the home front, special thanks go to my wife, Susan, and our children, Amy and Christopher, for their loving support. Without Chris's extensive computer knowledge, I definitely would have been forced to punt.

Finally, thanks go to my dad, Andrew Pitoniak, for taking me to my first Cuse game back in 1970. SU destroyed Miami 56-16 that sunny November afternoon, and I was hooked.

All photographs are provided courtesy of Syracuse University unless otherwise noted. All rights are reserved.

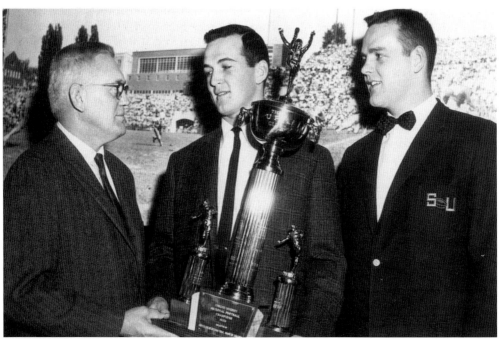

TRIUMPHANT TRIO. Legendary Syracuse University football coach Ben Schwartzwalder (left) is pictured with two of the stars of his 1959 national championship team, Gerhard Schwedes (center) and Roger Davis.

INTRODUCTION

It began long before there were football helmets, let alone a dome to protect the players' domes, and it began in painful fashion, with a few broken bones, plenty of bruised egos, and a lopsided loss. Shortly after Syracuse University's first-ever football game kicked off in Rochester, New York, on November 23, 1889, John Blake Hillyer, founder and captain of the team, was forced to the sidelines with a dislocated elbow. Minutes later, one of his teammates suffered a cracked collarbone. The tone clearly had been set early. The more experienced University of Rochester whipped the visitors from the Salt City 36-0, prompting one scribe to opine, "The Syracuse men showed a deplorable lack of team work and were no match for the home team."

As Hillyer and his mates boarded the locomotive for the trip home after that ignominious debut so many autumns ago, they were understandably disappointed, but they were not devastated. Out of their persistence, a football program was born.

In 1890, under the guidance of the school's first head coach, an English boxer named Robert Winston, SU posted an 8-3 won-lost record. The victory total included two redemptive shutouts against the Rochester club that had humiliated them the year before. During the next century and beyond, the Orangemen would field one of the most storied programs in college football history. They would produce a national championship in 1959, another unbeaten club in 1987, 21 bowl game appearances, a dozen College Football Hall of Fame inductees, and 651 victories.

The Cuse would also churn out 41 All-Americans. Among them have been Jim Brown, still the gold standard by which all running backs are measured; Ernie Davis, the Heisman Trophy winner whose life was cut tragically short by leukemia at age 23; Floyd Little, the three-time All-American who wore with distinction the No. 44 jersey that his predecessors, Brown and Davis, had worn; Vic Hanson, the only man to be inducted into both the college football and basketball halls of fame; Tim Green, the Rhodes Scholar finalist who became the "Leader of the Sack" as a two-time, All-American defensive end; Larry Csonka, the bulldozing fullback straight out of central casting; and Donovan McNabb, the cutting-edge quarterback with Houdini-like escape abilities and a heat-seeking missile arm.

Guiding these legendary players would be a string of legendary coaches that has included Ben Schwartzwalder, Buck O'Neill, Dick MacPherson, and Paul Pasqualoni. Along the way, the Orangemen have been cheered on by millions of fans at Archbold Stadium, the concrete bowl once referred to as "the eighth wonder of the world," and inside the Carrier Dome, the billowy-roofed stadium that has become a Syracuse landmark.

Written by someone who has followed the Orangemen since he was knee-high to a tackling dummy in the mid-1960s, this book has been a true labor of love. It is my sincere hope that the nearly 200 photographs and captions in *Syracuse University Football* will help readers back-pedal through time and give a clearer picture of one of the most successful and tradition-rich programs in college football history. Enjoy.

—Scott Pitoniak

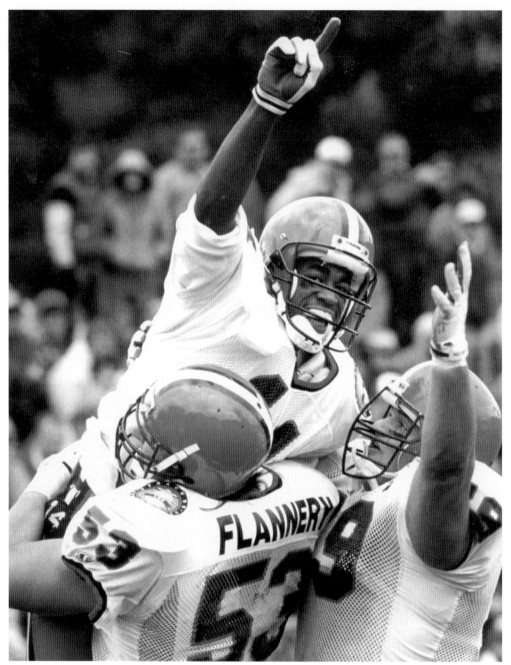

HE ALWAYS GAVE THEM MOORE. Rob Moore, shown leaping into the arms of teammates John Flannery and Blake Bednarz, became quite familiar with end-zone celebrations during his three seasons with the Orangemen. From 1987 to 1989, he caught 22 touchdown passes, the most ever by a Syracuse receiver.

One
First and Ten: Football Catches On at Syracuse

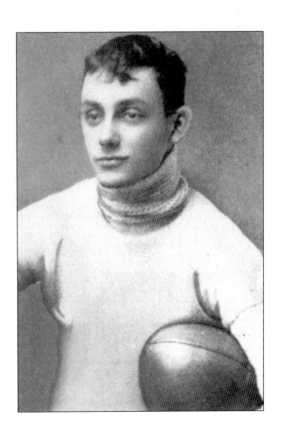

THE FATHER OF SU FOOTBALL. John Blake Hillyer was the driving force behind the formation of Syracuse's first official football team in 1889. Hillyer served as captain the first two seasons.

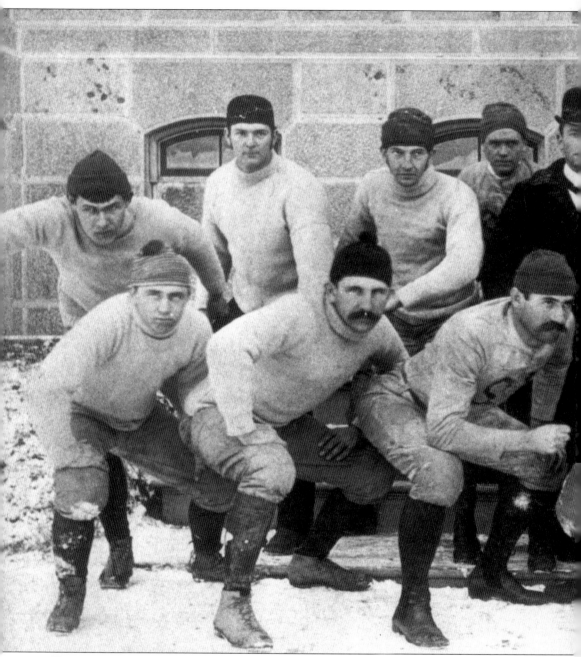
TRAILBLAZERS. After dropping the only game played during their inaugural season, a 36-0 decision at the University of Rochester, the Orangemen bounced back to go 8-3 in 1890.

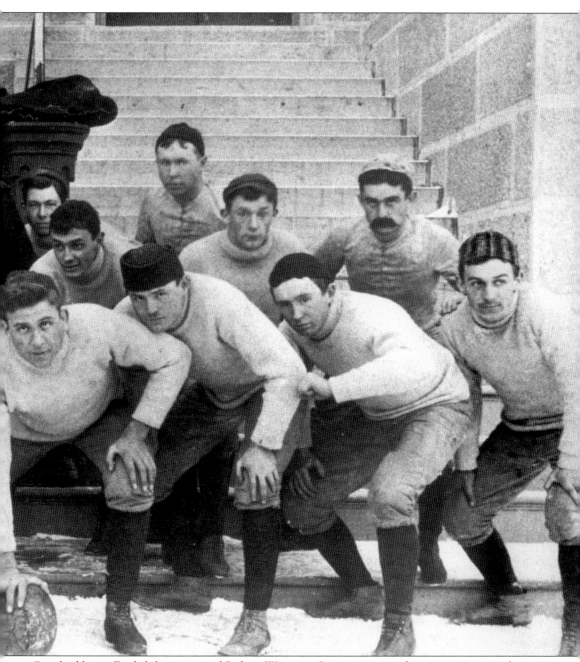
Coached by an English boxer named Robert Winston, Syracuse avenged its opening season loss by defeating Rochester twice that second season.

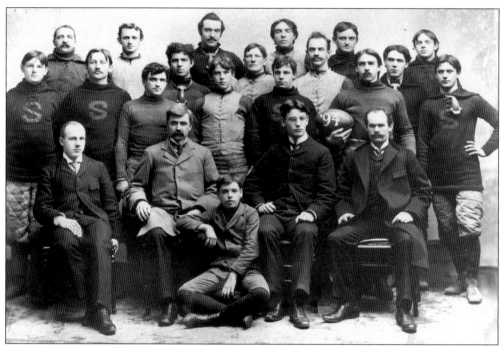

REVERSAL OF FORTUNE. The 1894 club went 6-5, snapping a streak of three consecutive losing seasons.

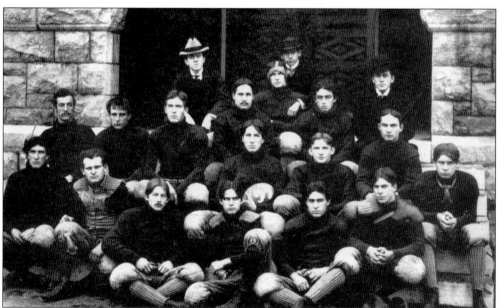

A FEUD TAKES ROOT. The 1897 Orangemen went 5-3-1. Their record could easily have been 6-3, had a reporter with allegiances to Colgate University not run onto the field and tackled a Syracuse player who was sprinting toward the potential game-winning touchdown. The officials looked the other way, and the game ended in a 6-6 tie. A fierce football rivalry between the two upstate New York schools would ensue.

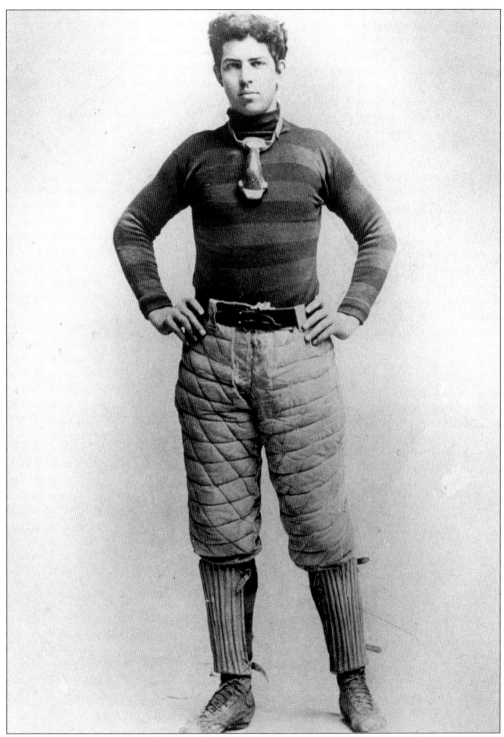

SARTORIAL SPLENDOR. William Smallwood, who earned four letters in football between 1896 and 1899, models the Syracuse uniform of the late 19th century. Those were the days before helmets and heavy padding, but players did wear nose guards.

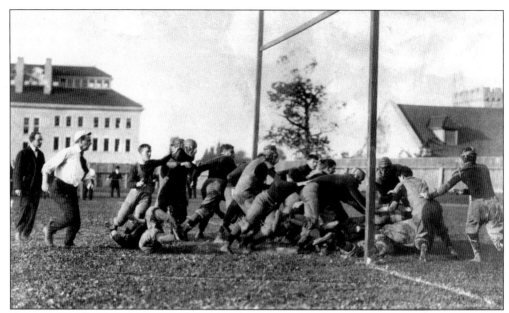

OVAL TIME. The Orangemen are shown in action against Colgate University during a 1905 game at SU's Old Oval, not far from one of the campus's enduring landmarks, the Hall of Languages.

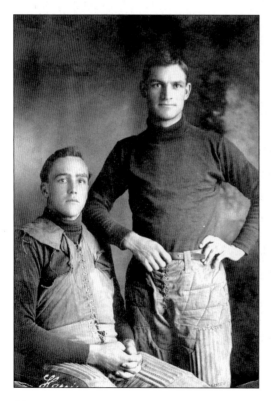

CO-CAPTAINS. Cornelius Day (left) and Robert Park were captains of the 1904 team that went 6-3 and averaged 45 points per contest. One of the Orangemen's victories was a 144-0 annihilation of Manhattan College, the most lopsided win in SU history.

Two
A Pigskin Palace Called Archbold Stadium

Archbold Stadium. John D. Archbold, who rose from abject poverty to enormous wealth, contributed more than $4 million to Syracuse University. Half of his endowment was used to construct the 40,000-seat football stadium that would bear his name.

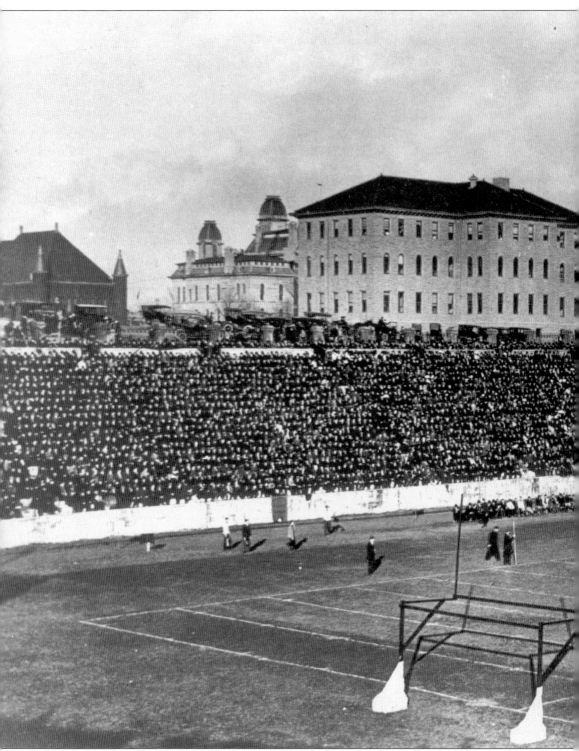

"EIGHTH WONDER OF THE WORLD." That is how sportswriters referred to Archbold Stadium

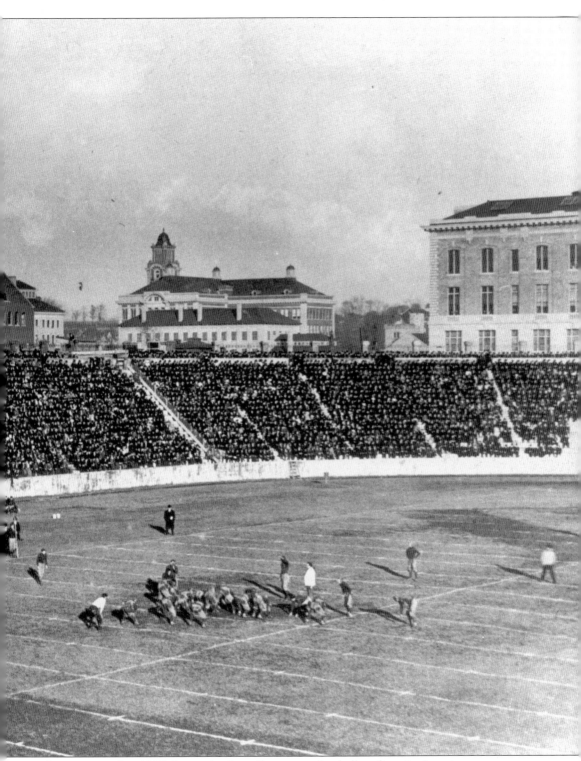
when it opened in 1907. It was the first all-concrete football stadium in America.

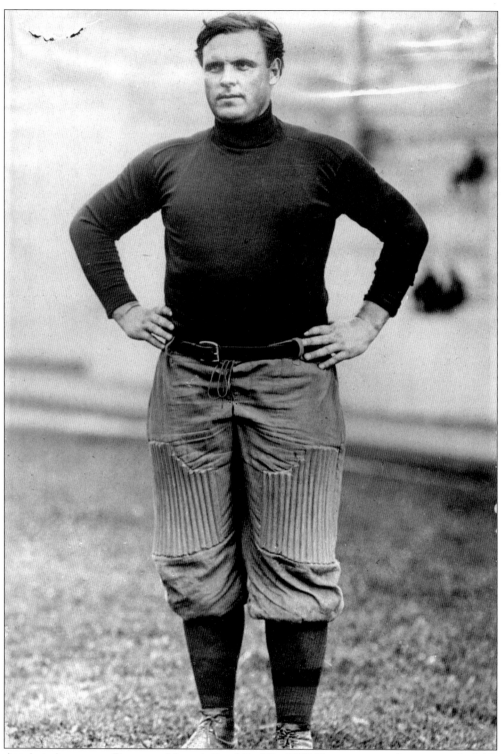

AN ALL-AMERICAN PIONEER. Marquis Franklin "Big Bill" Horr was a six-foot two-inch, 240-pound tackle who became SU's first All-American in 1908.

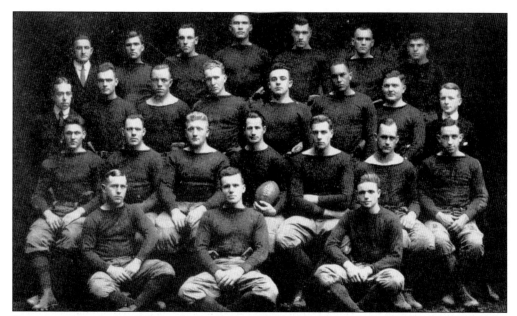

SMELLING LIKE ROSES. Under the guidance of Hall of Fame coach Frank "Buck" O'Neill, the 1915 team recorded nine shutouts en route to a 9-1-2 record. The squad received an invitation to play in the Rose Bowl but turned it down because a trip to the West Coast earlier in the season had depleted the school's athletic budget.

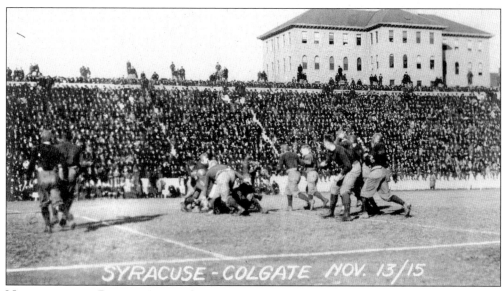

NEIGHBORHOOD RIVALS. Among SU's nine victories in 1915 was a 38-0 blanking of Colgate University before 25,000 spectators at Archbold Stadium.

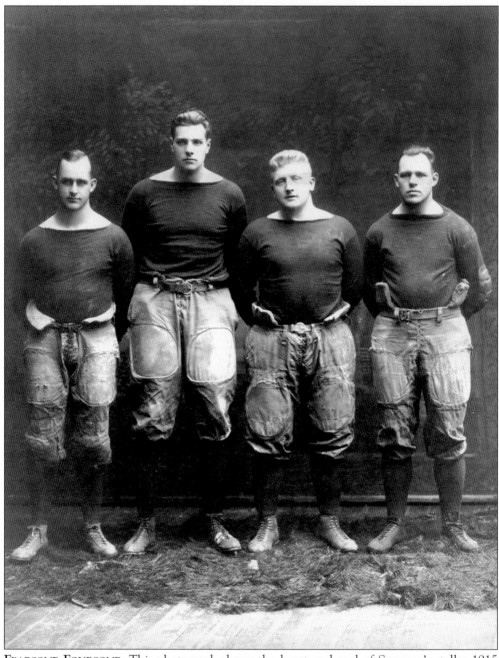

FEARSOME FOURSOME. This photograph shows the heart and soul of Syracuse's stellar 1915 squad. From left to right are T.R. Johnson, Babe White, Chris Schlachter, and Ty Cobb. Together, they weighed nearly half a ton.

THIS BUCK STOPPED HERE. Frank "Buck" O'Neill was SU's first big-name football coach. He had three different stints at the school, guiding the Orangemen to a 52-19-6 record in eight seasons. He was inducted into the College Football Hall of Fame in 1951.

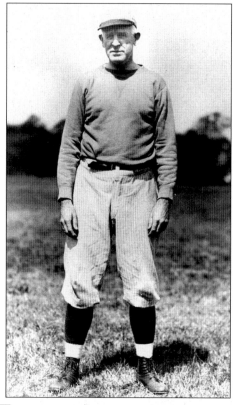

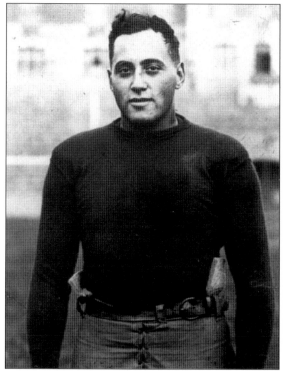

ALEXANDER THE GREAT. Joe Alexander played for coach Buck O'Neill between 1916 and 1919, earning All-American honors at guard three times. Alexander was the first Syracuse player inducted into the College Football Hall of Fame, in 1954.

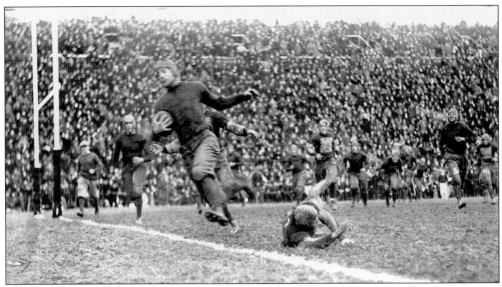

HEADING FOR PAY DIRT. Syracuse's Bill Ewing scores a touchdown during a 1919 game at Archbold. The Orangemen went 8-3 that season.

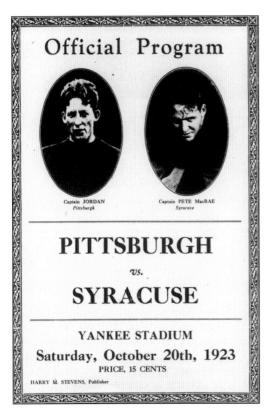

BIG APPLE SHOWDOWN. In a classic defensive struggle before 35,000 spectators at Yankee Stadium on October 20, 1923, the Orangemen defeated Pittsburgh 3-0.

A REAL WINNER. Roy Simmons Sr. quarterbacked the Orangemen to a 22-4-3 record from 1922 to 1924. He later coached SU to national titles in lacrosse and boxing and served as an assistant to the Cuse's 1959 college football championship team.

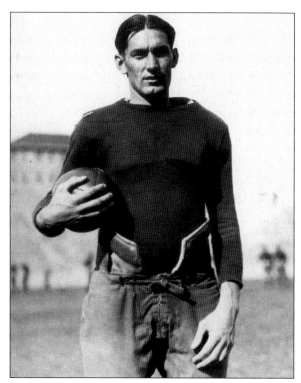

TRUE TO HIS SCHOOL. Lew Andreas was a star player on the 1919–1920 football squads that combined to go 14-5-1. He stayed on at his alma mater as a coach and athletic director. He is second only to current SU basketball coach Jim Boeheim in victories.

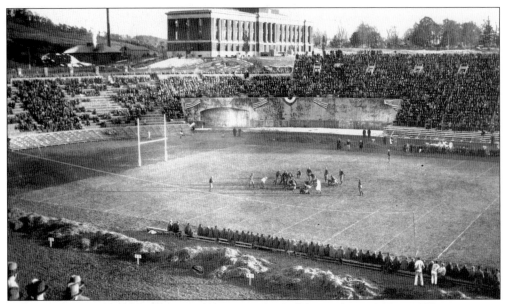

OLD ARCHIE. Archbold Stadium served as SU's football home from 1907 to 1978.

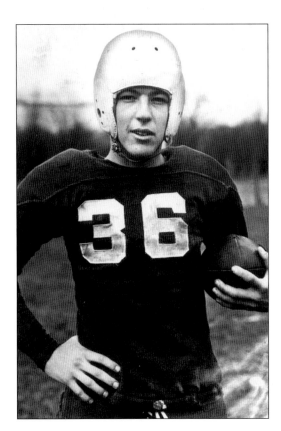

YOU CAN'T GO HOME AGAIN. Reeves Baysinger was a star player on Syracuse's powerhouse teams in the early 1920s. He later served as head coach at his alma mater, but it was not a pleasant experience. His teams went a combined 4-14 in 1947 and 1948.

HALE TO THIS VICTOR. Vic Hanson, pictured here as a player and as a coach, is regarded by some as the greatest athlete ever to play at Syracuse University. An All-American end in football in 1926, Hanson also helped lead the Orangemen to a national basketball championship. He is the only player who has been inducted into both the basketball and college football halls of fame. He also coached football at his alma mater, guiding SU to a 33-21-5 record from 1930 to 1936.

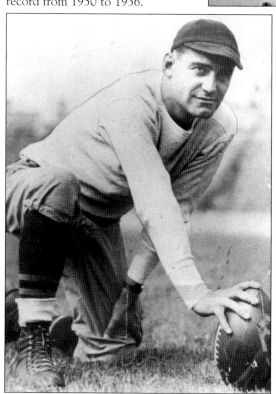

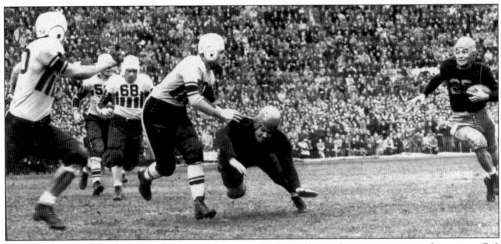

THE FASTEST KID ON THE BLOCK. Marty Glickman, shown here gaining yardage in a 7-0 victory against Colgate in 1938, was an Olympic sprinter capable of going the distance any time he touched the ball. His 80-yard touchdown run against Maryland in 1938 remains the fourth-longest scoring play in SU history. Glickman would go on to gain even greater fame as one of America's premier sportscasters.

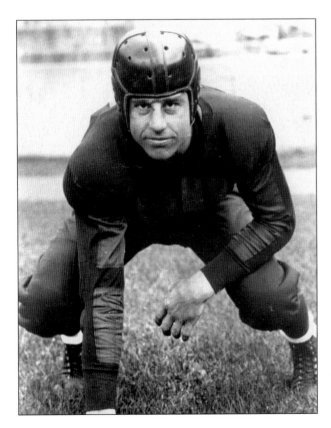

STEEN THE ALL-AMERICAN. Jim Steen earned All-American honors as a tackle for a 1934 SU team that went 6-2 and recorded four shutouts.

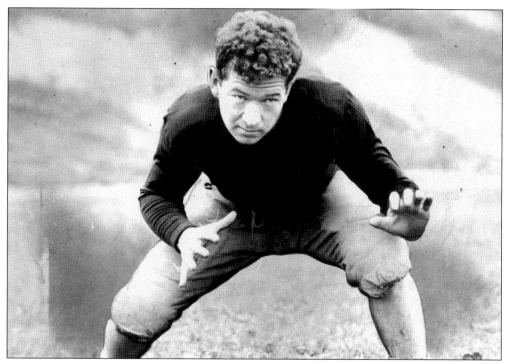

INFECTIOUS SPIRIT. Long before gaining fame as a Hall of Fame coach at Michigan State, Duffy Daugherty played football at Syracuse, earning letters from 1936 to 1939 and serving as team captain his senior season. Daugherty was beloved by his coaches and teammates for his hustle and competitive spirit. Since 1987, the SU coaching staff has presented an annual enthusiasm award in Daugherty's honor to one of its players.

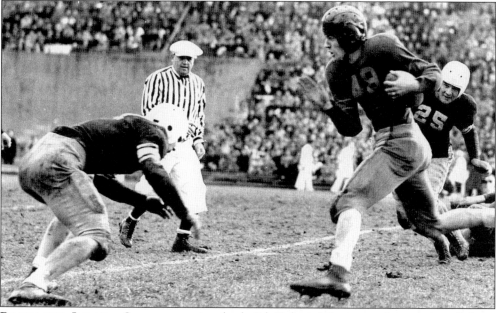

READY FOR IMPACT. Syracuse running back Ed Dolan picks up yardage against Colgate University in a 1944 game at Archbold Stadium. The Orangemen won the game 43-13.

COMEBACK KID. Wilmeth Sidat Singh, believed to be the first African American to play quarterback at a major college, guided Syracuse to three touchdowns in the final six minutes as the Orangemen defeated Cornell University 19-17 in a 1938 game. Legendary sportswriter Grantland Rice called it the most exciting football game he had ever seen.

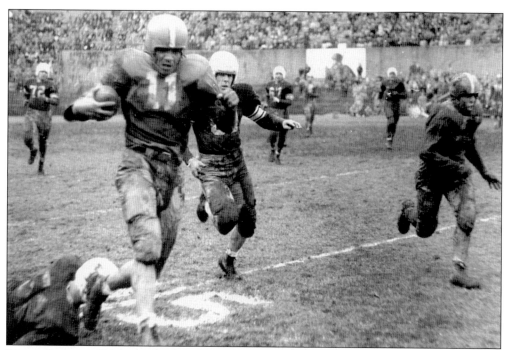

LONG GAINER. SU quarterback Bernie Custis picks up big yardage during a game against Colgate University in the 1940s.

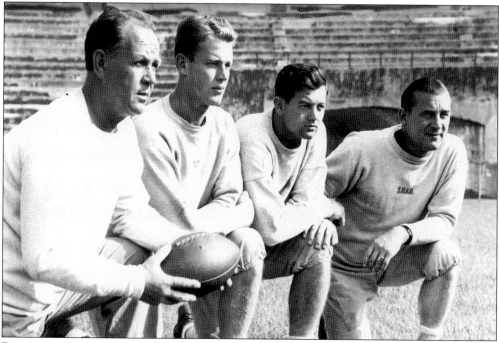

BUDDING CAREER. Bud Wilkinson (second from the left) began his Hall of Fame coaching career as an assistant at Syracuse in 1941. Wilkinson went on to win three national championships with the Oklahoma Sooners. Also pictured are, from left to right, Ossie Solem, Robert Lannon, and William Boelter.

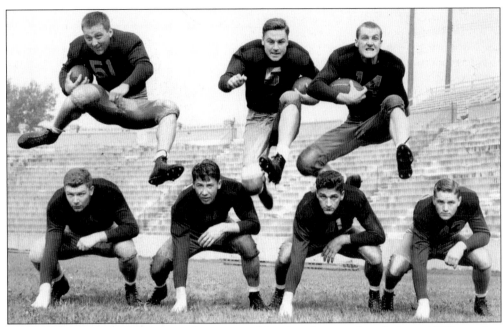

LEAP OF FAITH. The Orangemen clown around for the photographer during a 1939 practice. The leaping backs are, from left to right, Leo Canale, Bill Hoffman, and Dick Banger. The linemen are, from left to right, William Heater, Tony Paskevich, Bill Mazur, and Dick Dudley.

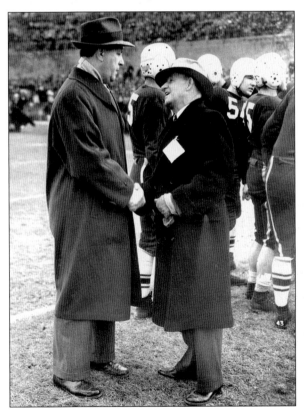

RIVAL COACHES. Syracuse coach Ossie Solem (left) exchanges pregame pleasantries with Andy Kerr, the Hall of Fame coach from Colgate University, before a 1941 game at Archbold.

WALTER THE GREAT. Walter Slovenski, who played at SU from 1946 to 1948, ranks third all-time in school history with 13 interceptions. In a 1946 game against Temple University, he returned two picks for a total of 108 yards—a school record that still stands.

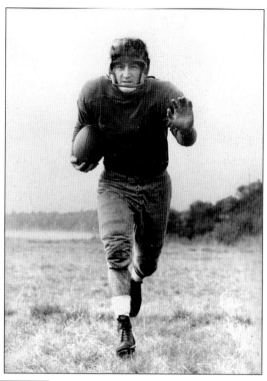

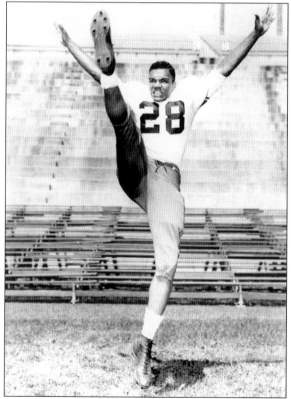

GETTING HIS KICKS. Avatus Stone is shown here punting, but he made his mark more as a defensive back. During his two seasons with the Orangemen (1950 and 1951), Stone intercepted 12 passes, fourth-best in school history.

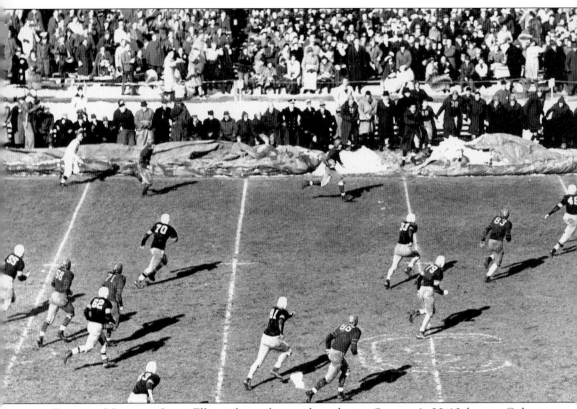

SHINING MOMENT. Larry Ellis picks up big yardage during Syracuse's 20-13 loss to Colgate University in 1948. It was one of the few highlights of a season that saw the Orangemen win just one of nine games.

Three
OL' BEN COMES TO THE RESCUE

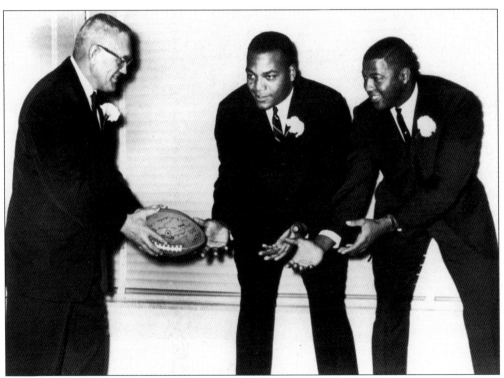

HALL OF FAME HANDOFF. SU coaching legend Ben Schwartzwalder prepares to hand the football off to Jim Brown (center) and Ernie Davis, two of the running backs who helped him return Orange football to national prominence. Schwartzwalder inherited a moribund program in 1949 and had transformed the Orangemen into national champions 10 years later. SU went 153-91 in his 25 seasons.

BOWLING THEM OVER. The Orangemen went 7-2 in 1952 and accepted a bid to play Alabama

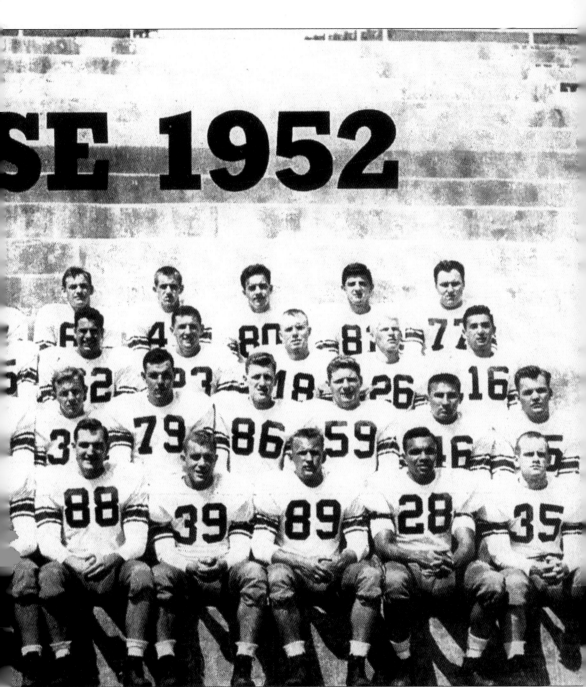

in the Orange Bowl. It was not a pleasant experience, as the Crimson Tide rolled SU 61-6.

CATCHING ON. Joe Szombathy led Syracuse in receiving from 1950 to 1952. He scored SU's only touchdown on a 15-yard pass from Pat Stark, in a 61-6 loss to Alabama at the 1953 Orange Bowl. Szombathy later served as an assistant football coach and leader of the Orange Pack, the school's official athletic fundraising group.

STARK REALITY. Pat Stark, the first SU quarterback to be drafted by the National Football League, threw 19 touchdown passes in his two years as a starter at SU. His four touchdown tosses in a 1952 game against Fordham is a school record.

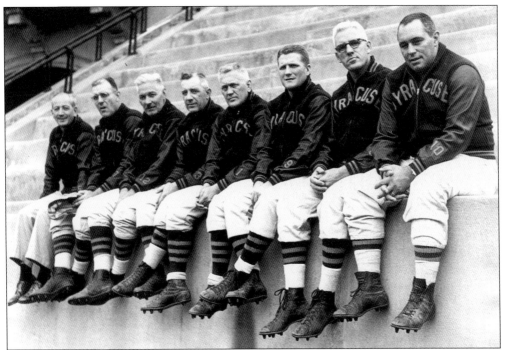

BEN'S BOYS. Ben Schwartzwalder (fifth from the left) poses with the members of his SU staff. They are, from left to right, Julie Reichel, Bill Eschenfelder, Roy Simmons, Ted Dailey, Bill Bell, Les Dye, and Rocco Pirro.

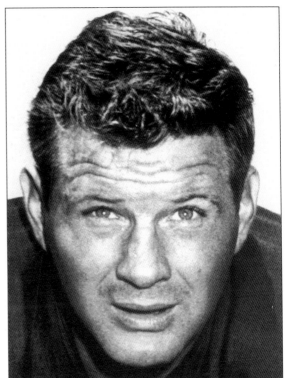

RINGO STAR. Jim Ringo, a gritty, hard-nosed center for the Syracuse teams of the early 1950s, is one of five alumni enshrined in the Pro Football Hall of Fame in Canton, Ohio. The four others are Jim Brown, Larry Csonka, Al Davis, and John Mackey.

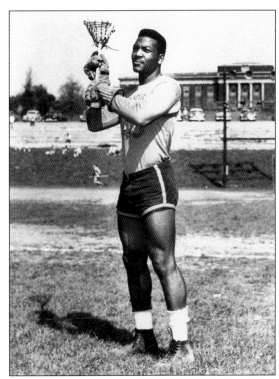

MULTITALENTED. Jim Brown made his mark on the football field, but he was also a superb lacrosse player and basketball player at Syracuse. Some regard him not only as the greatest football player of all time but also as the finest lacrosse player in history.

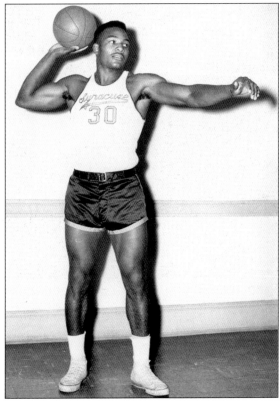

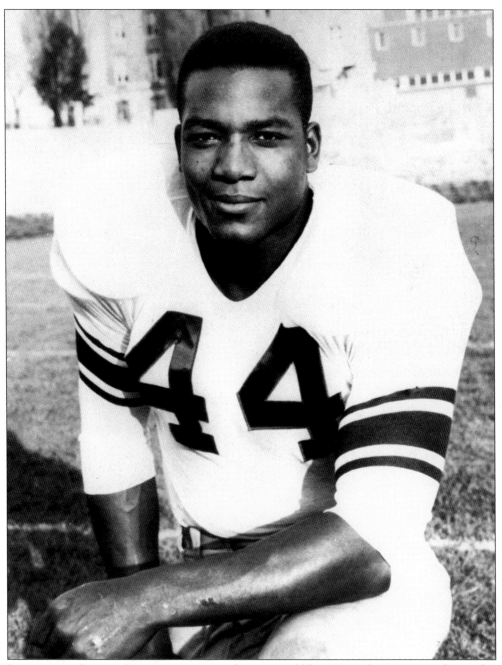

JIMMY THE GREAT. Jim Brown averaged an incredible 5.8 yards per carry during his Syracuse career.

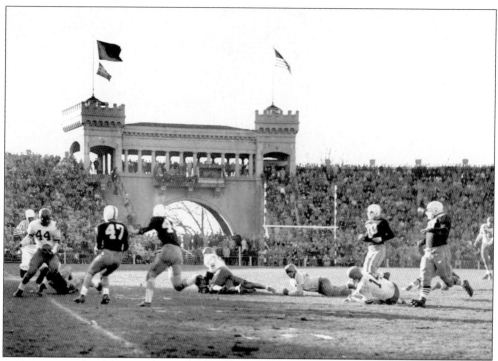

BROWNOUT. Jim Brown is forced out-of-bounds after a big gain against Penn State during a 1956 game at Archbold Stadium.

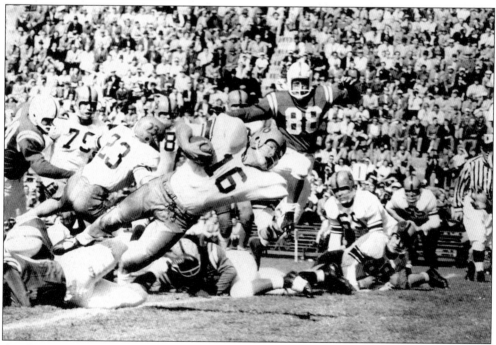

AN ARTIST'S TOUCH. A member of SU's All-Century team, Jim Ridlon, shown here lunging for the goal line, ranks eighth all-time in interceptions with 11. He played eight seasons in the National Football League, before returning to his alma mater to teach art.

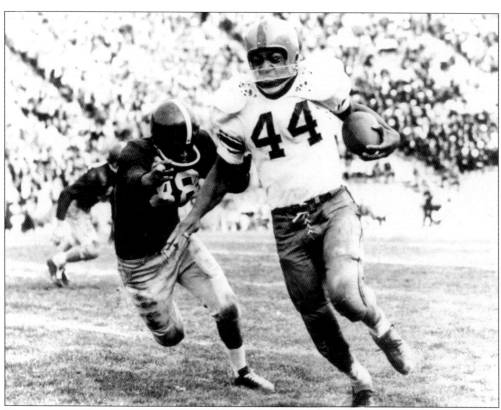

HITTING THE HIGH NOTES. Jim Brown turned in a virtuoso performance in his final game with Syracuse, the 1957 Cotton Bowl game against Texas Christian University. The Orangemen lost 28-27, but Brown (seen running the ball in the photograph above) finished the day with 132 yards rushing, two touchdowns, and three extra points to earn MVP honors. To the right, Brown and teammates Ferdy Kuczaca (left) and Rudy Farmer (center) unwind at a piano before the game.

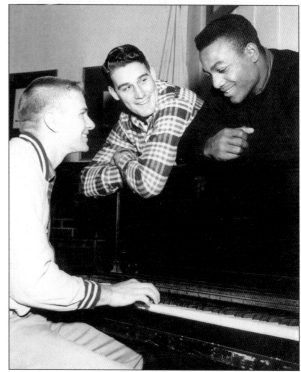

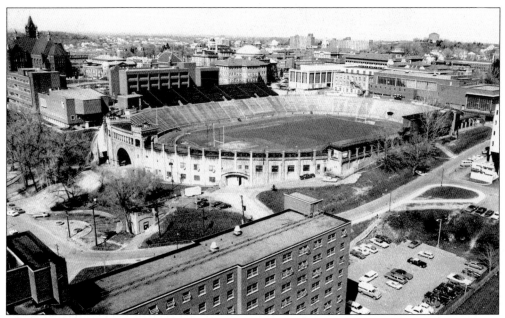

THE BIG HOUSE. Syracuse recorded a 259-105-20 record in its 71 seasons at Archbold Stadium.

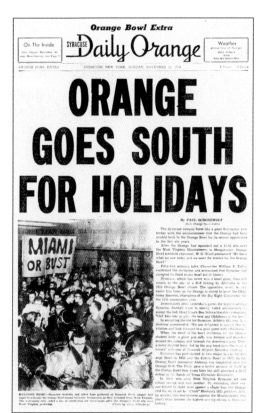

FLORIDA BOUND. As the school newspaper, the *Daily Orange*, announced, the Syracuse football team had received a bid to the 1958 Orange Bowl in Miami. The trip would not prove fruitful, as SU would lose to Oklahoma 21-6.

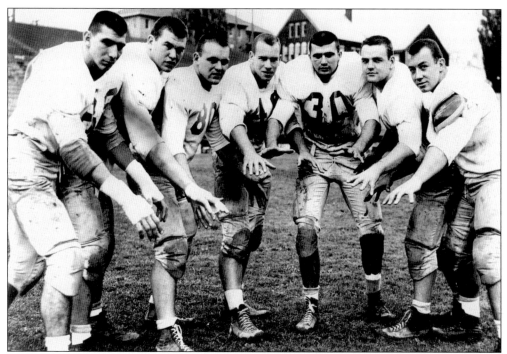

THE SIZEABLE SEVEN. The offensive line from SU's 1959 national championship team is regarded as one of the best in college football history. Shown here are, from left to right, All-American Fred Mautino, Maury Youmans, All-American Bob Yates, Bruce Tarbox, Al Bemiller, All-American Roger Davis, and Gerry Skonieczki.

FABULOUS FRED. Fred Mautino earned All-American honors at end for SU's 1959 national champions.

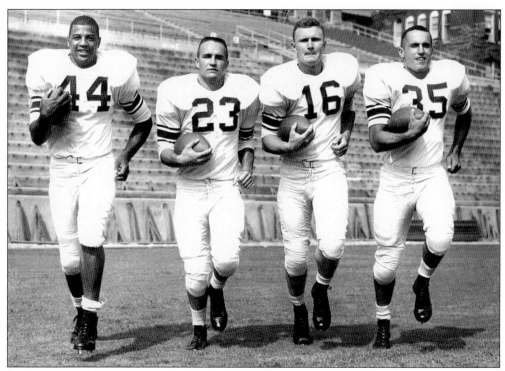

BACKFIELD IN MOTION. SU's backfield during the 1959 season included, from left to right, Ernie Davis, Dave Sarette, Peter Brokaw, and Gary Fallon.

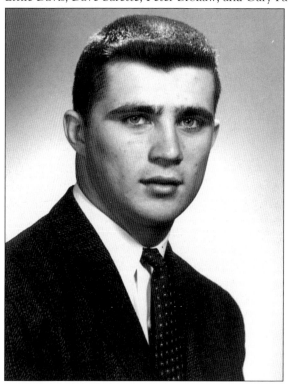

CENTER OF ATTENTION. Al Bemiller earned All-American honors at center for the 1959 national championship team. He went on to play for the Buffalo Bills and was named the starting center on its silver anniversary team.

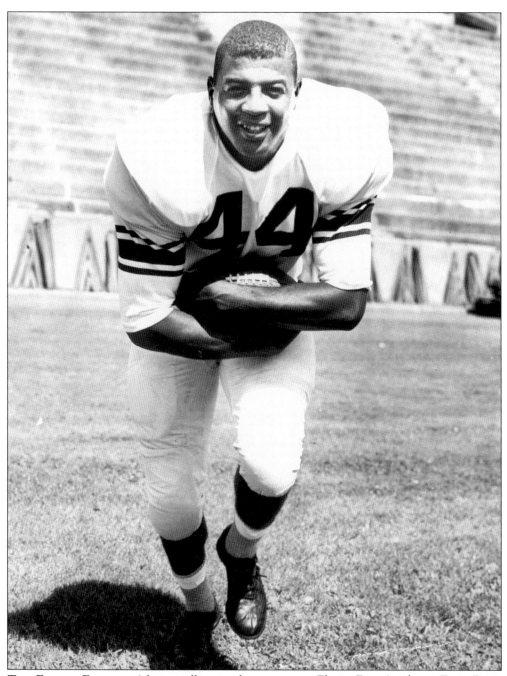

THE ELMIRA EXPRESS. After excelling in three sports at Elmira Free Academy, Ernie Davis chose to follow in the cleatsteps of Jim Brown at Syracuse University. Wearing the same number that Brown had made famous, Davis went on to eclipse most of his predecessor's school records.

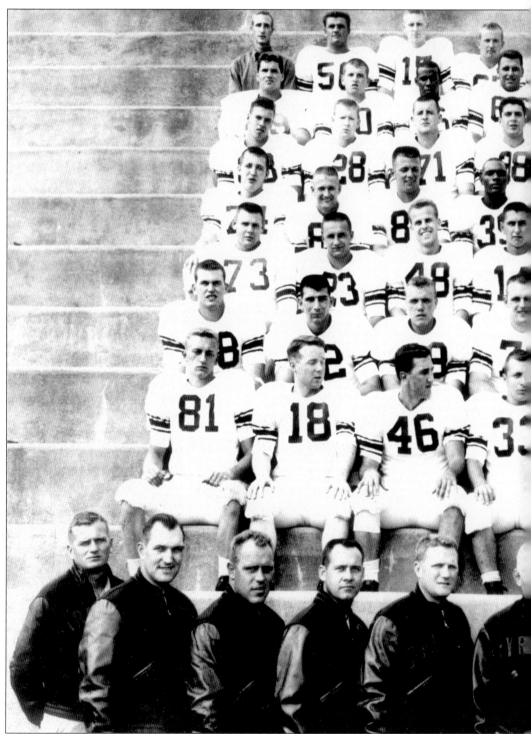

THAT CHAMPIONSHIP SEASON. The 1959 team went 10-0 during the regular season, outscoring its opponents 390-59. After watching Syracuse crush UCLA 36-8 in the regular-season finale, one sportswriter said that the Orangemen's talent was so abundant that he was going to vote

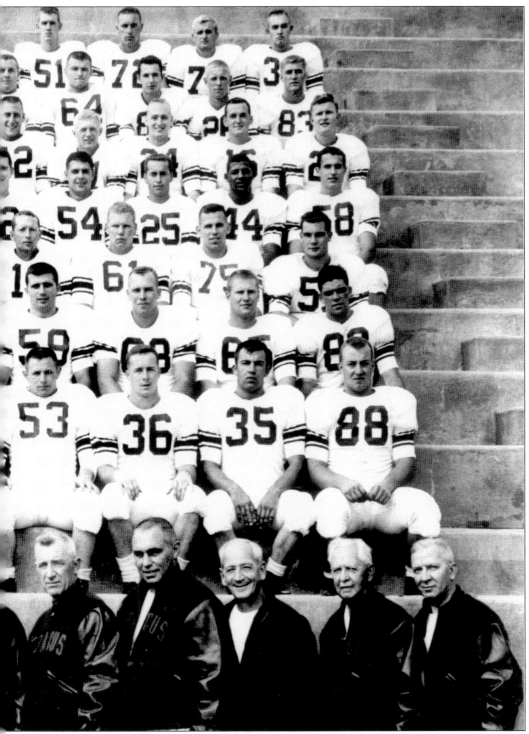

their first unit number one and their second unit number two in the Associated Press's weekly national college football poll. Coach Ben Schwartzwalder's squad capped its perfect season with a 23-14 victory against Texas in the Cotton Bowl.

ROGER AND OUT. Guard Roger Davis won All-American honors for Syracuse in 1959.

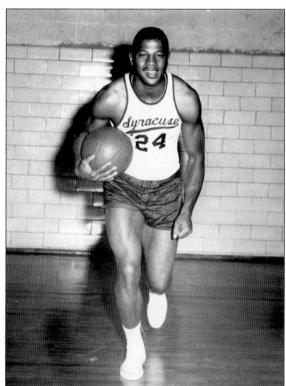

HOOPLA. Ernie Davis was such a good basketball player in high school that several colleges recruited him solely for that sport. Davis lettered in basketball at SU in 1961.

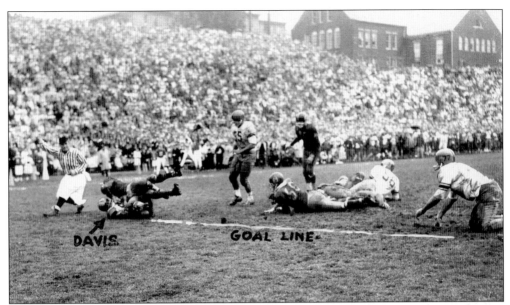

REACHING HIS GOAL. Ernie Davis scores a touchdown during a 28-9 victory against Pitt in 1961 at Archbold Stadium.

OUT OF HIS LEAGUE. Dave Meggysey started three seasons at Syracuse and played linebacker for the St. Louis Cardinals in the National Football League for seven seasons. He later authored a controversial book about the brutality of football.

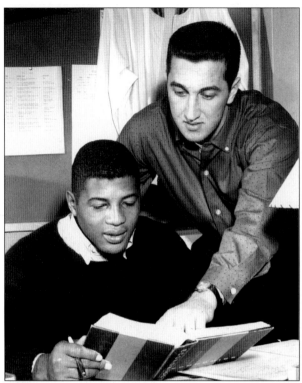

TACKLING THE BOOKS. Ernie Davis (left) and teammate Mark Weber cram for an exam during the fall of 1959.

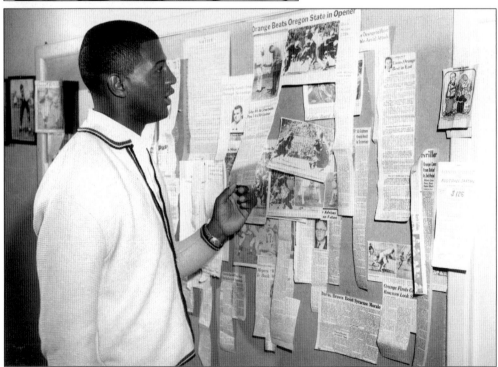

PRESS CLIPPINGS. By his senior season, Ernie Davis had become one of the most written-about players in college football.

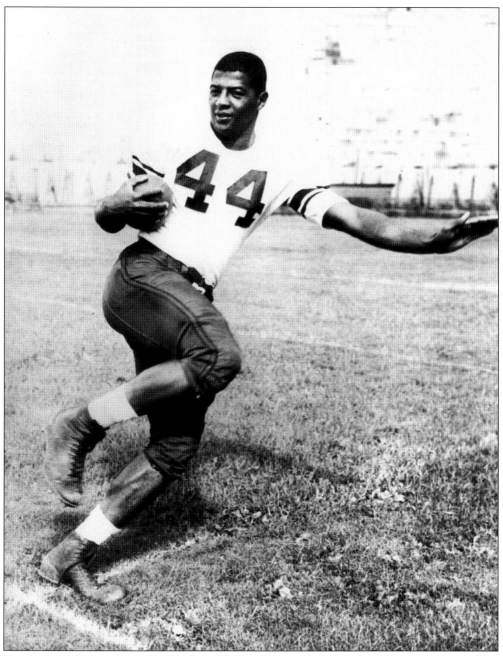
STRIKING A POSE. Ernie Davis, the eighth-leading rusher in school history, averaged an astounding 6.6 yards per carry during his career.

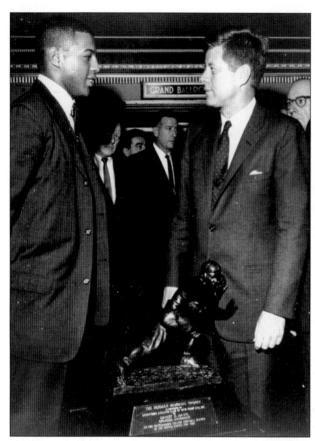

MEETING JFK. Not long after receiving the Heisman Trophy at the Downtown Athletic Club in New York City, Ernie Davis met Pres. John F. Kennedy.

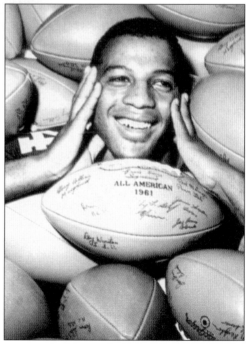

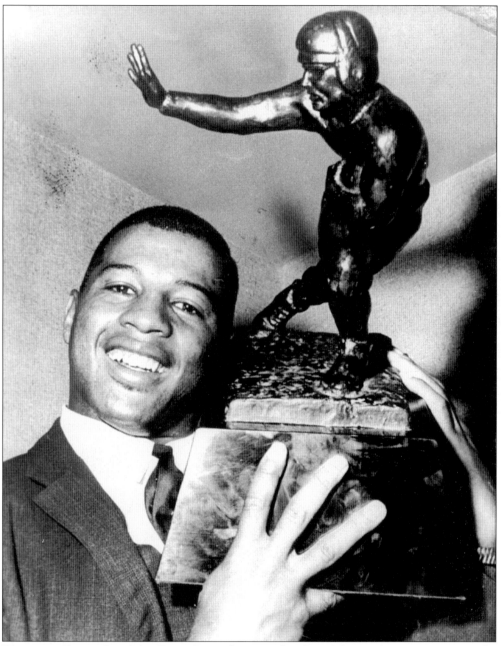

HISTORIC FIRST. In 1961, Ernie Davis became the first African American to win the Heisman Trophy.

SIR WALTER. Walt Sweeney was a three-year starter at guard for the Orangemen, opening holes for All-American running back Ernie Davis during the 1960 and 1961 seasons. Named to SU's All-Century team, Sweeney was a first-round draft pick of the San Diego Chargers in 1963. He had a distinguished professional career, earning All-Star honors eight times. Sweeney was named to the American Football League's All-Time team.

BIG JIM. Jim Nance continued the Syracuse tradition of big, bruising fullbacks. Nance, a former National College Athletic Association heavyweight wrestling champion, led the team in rushing in 1965. He went on to have an outstanding professional career with the Boston Patriots.

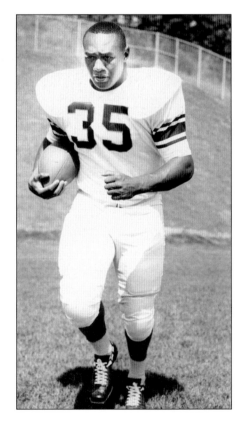

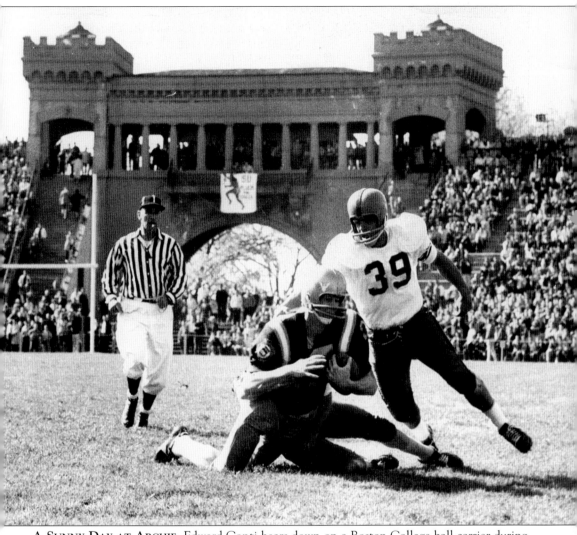

A Sunny Day at Archie. Edward Conti bears down on a Boston College ball carrier during a 12-0 victory in a 1962 game at Archbold Stadium.

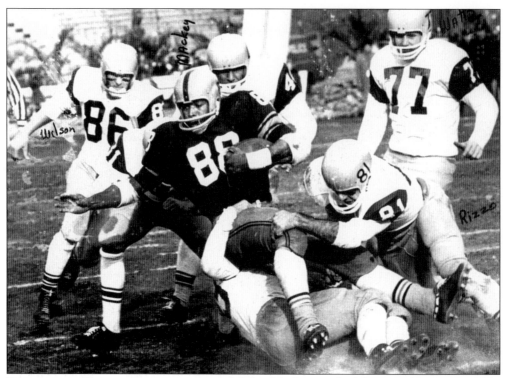

DRAWING A CROWD. Syracuse tight end John Mackey made life miserable for would-be tacklers. During this 1962 game, five defenders converge on him after the catch. Mackey went on to star for the Baltimore Colts. Regarded by many as the greatest tight end of all time, Mackey was inducted into the Pro Football Hall of Fame in 1992.

RIGHT GUARD. Gary Bugenhagen earned All-American honors at guard while clearing a path for Floyd Little and Larry Csonka in 1966.

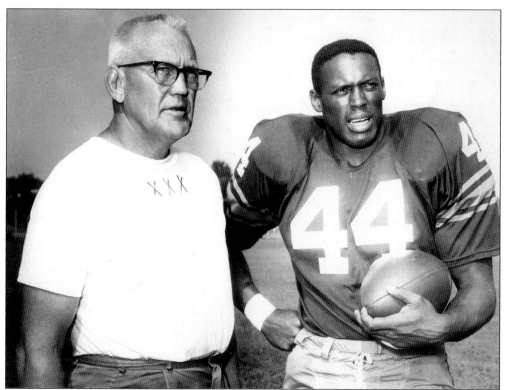

THE TRADITION CONTINUES. Syracuse coach Ben Schwartzwalder (left) felt triply blessed when Floyd Little lined up in 1964 and carried on where Jim Brown and Ernie Davis had left off.

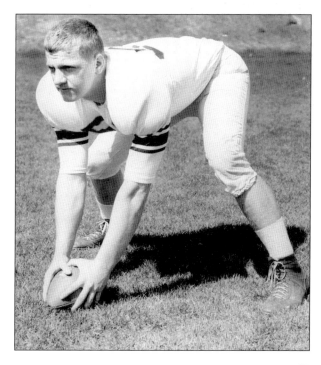

CENTER STAGE. Pat Killorin, from Watertown, New York, earned All-American honors at center in 1964 and 1965.

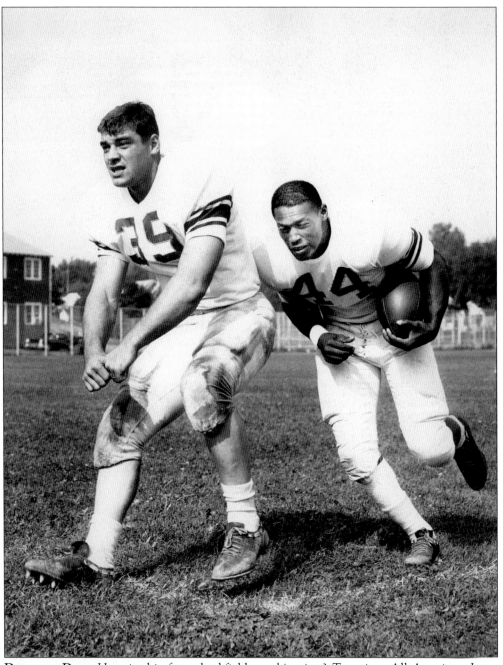

Dynamic Duo. How is this for a backfield combination? Two-time All-American Larry Csonka (No. 39) is at fullback, and three-time All-American Floyd Little is at halfback.

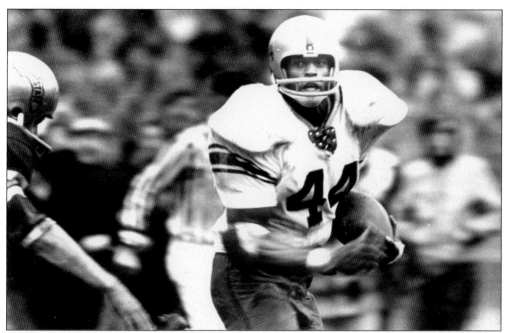

A LITTLE GOES A LONG WAY. Floyd Little would wind up shattering the records established by his predecessors, Jim Brown and Ernie Davis. On SU's all-time lists, he ranks fourth in rushing, second in punt returns, and third in scoring.

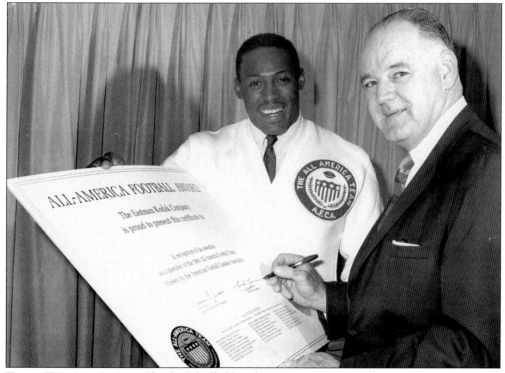

THIRD TIME'S A CHARM. Floyd Little (left) is shown receiving his All-American certificate in 1966. He joined Bill Horr as the only three-time All-American selection in SU football history.

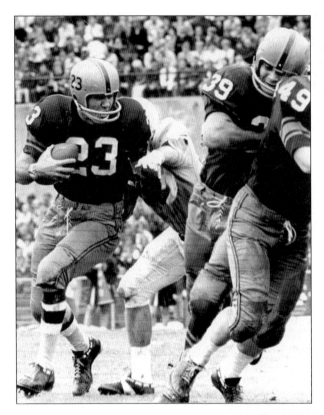

TRAFFIC DIRECTOR. Quarterback Rick Cassata knew that his primary job was to hand the ball off to Floyd Little and Larry Csonka and get the heck out of the way. He did a great job, but he also provided the Orangemen with a big run or pass on occasion.

TOM TERRIFIC. Wingback Tom Coughlin did not see the ball much during his three years of varsity football because it was usually given to backfield mates Floyd Little or Larry Csonka. Coughlin, however, still managed to establish himself as a team leader and solid contributor. He went on to gain acclaim as a successful, hard-nosed head coach at Boston College and with the Jacksonville Jaguars.

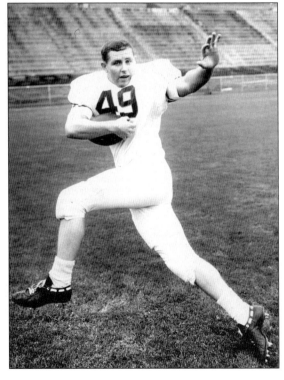

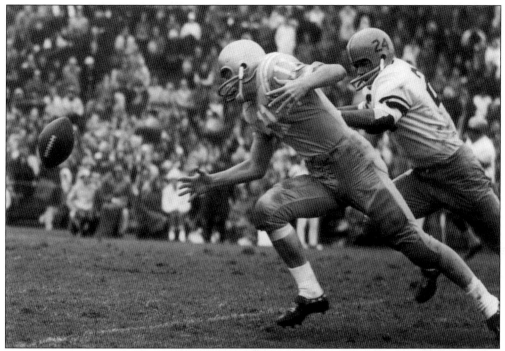

FUMBLE. Syracuse defensive back Hal Rooney scrambles after a loose ball during a 38-0 trouncing of UCLA at Archbold Stadium in 1964.

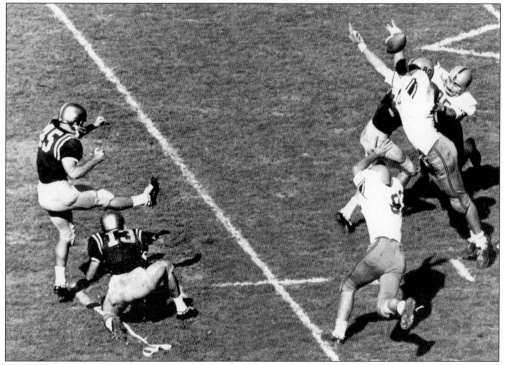

AN ARTFUL BLOCK. Art Thoms, a member of SU's All-Century team, blocks a field goal attempt during a 27-14 loss to Navy in 1967.

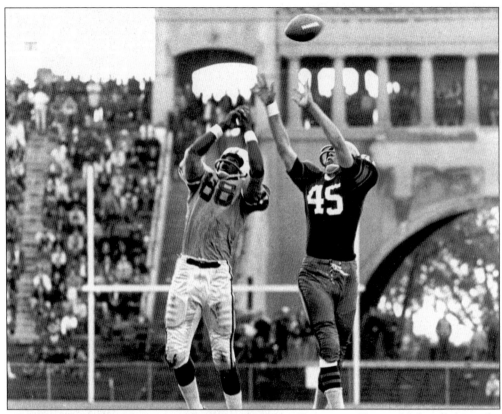

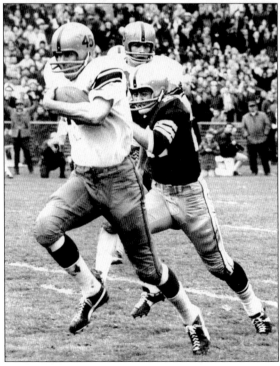

TONY THE TIGER. In the photograph above, All-American defensive back Tony Kyasky (No. 45) breaks up a pass during a 23-6 victory against West Virginia in a 1967 game at Archbold. To the left, Kyasky returns an interception.

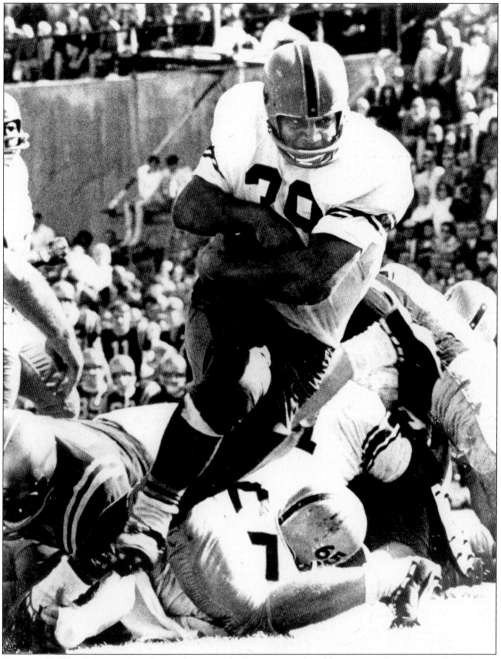
Csonk. Fullback Larry Csonka ranks second all-time in school history with 2,934 yards rushing. He went on to have a Hall of Fame career with the Miami Dolphins.

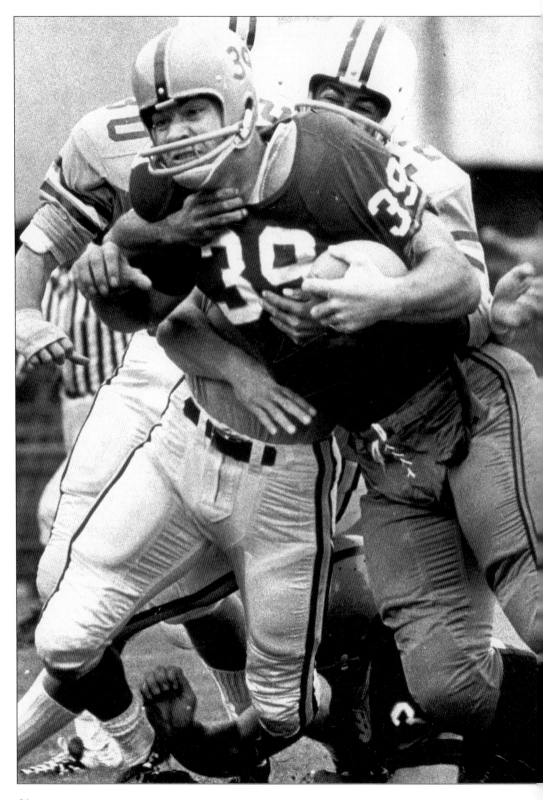

BULL RUN. Larry Csonka, a brutish six-foot three-inch, 245-pound fullback, is shown here dragging several defenders with him. A punishing runner, Csonka once lugged the ball a school-record 43 times in a 1967 game against Maryland, gaining 216 yards along the way.

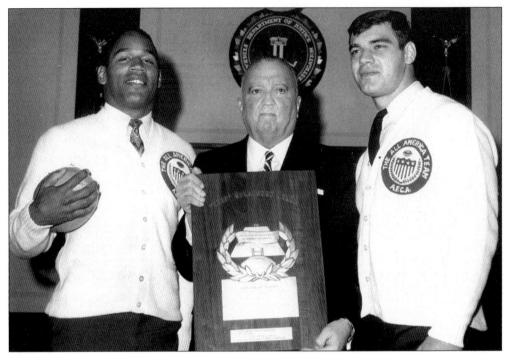

POSTSEASON HONORS. Larry Csonka (right) is pictured with O.J. Simpson and late FBI director J. Edgar Hoover at an All-American football awards banquet. Csonka twice earned first-team honors at fullback.

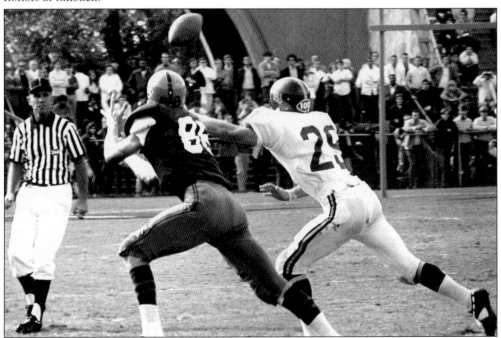

A STEP AHEAD OF THE COMPETITION. Tight end Tony Gabriel twice led the Orangemen in receiving. His best season was his senior year, when he averaged 14.4 yards per catch and scored seven touchdowns.

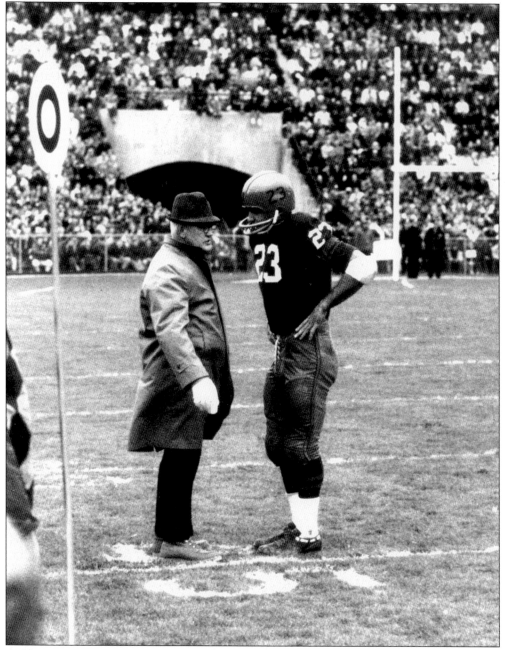

A MEETING OF THE MINDS. Coach Ben Schwartwalder confers with his quarterback, Rick Cassata, during a 1966 game at Archbold Stadium.

JOLTING JOE. Defensive tackle Joe Ehrmann earned All-American honors in 1970 before heading off to the National Football League, where he played for nearly a decade with the Baltimore Colts.

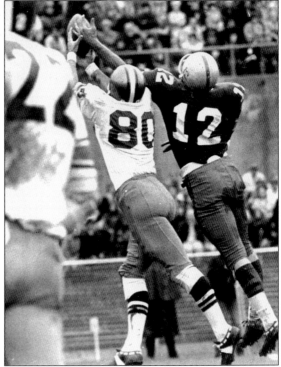

NOT ON MY WATCH. Syracuse All-American defensive back Tommy Myers breaks up a pass during a 1969 game at Archbold Stadium. A member of SU's All-Century team, Myers is the Orangemen's second-leading interceptor of all time with 18.

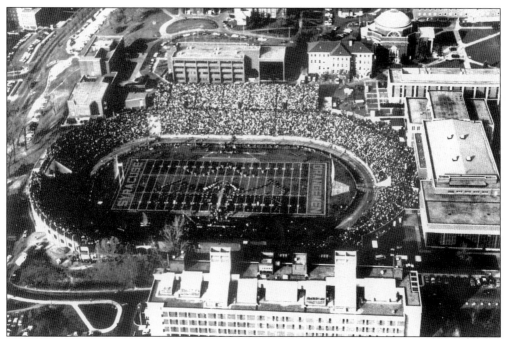

FULL HOUSE. For seven decades, Archbold Stadium was a campus hot spot on fall Saturday afternoons.

CAPTAIN DAVE. Dave Lapham was a three-year starter and All-East selection at tackle for Syracuse. Lapham was co-captain of the Orangemen in 1973, coach Ben Schwartzwalder's final season. Lapham spent nine years with the Cincinnati Bengals.

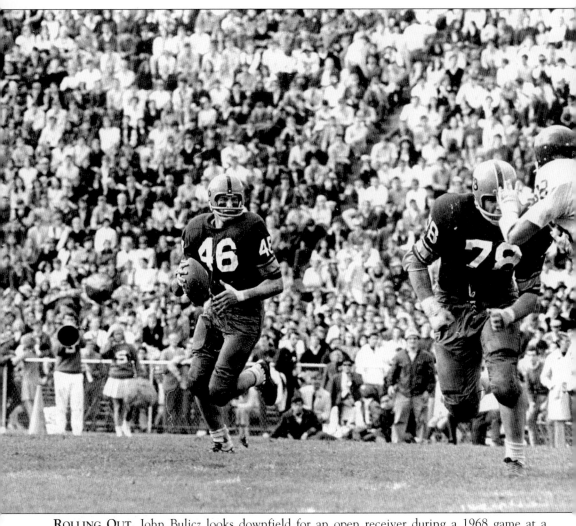

ROLLING OUT. John Bulicz looks downfield for an open receiver during a 1968 game at a packed Archbold Stadium.

Four
Transition Time

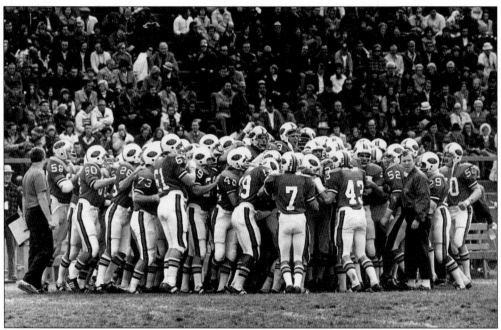

Huddle Up. New Syracuse head coach Frank Maloney and his team gather together before the opening kickoff of the 1974 season. Maloney, who was replacing the legendary Ben Schwartzwalder, guided his players to a 23-15 victory against Oregon State that afternoon. The Orangemen, however, would win only one more game the rest of the way, finishing 2-9.

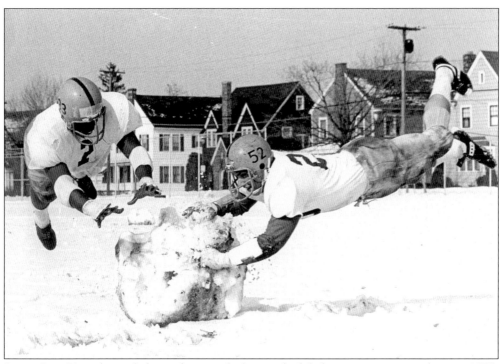

SNOW JOB. Two players frolic in the snow before a scheduled spring practice workout in 1975.

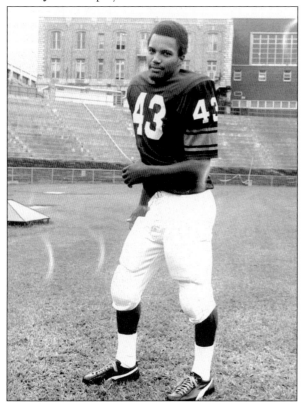

MANY HAPPY RETURNS. Keith Moody intercepted six passes and returned a punt for a touchdown during his senior season in 1975.

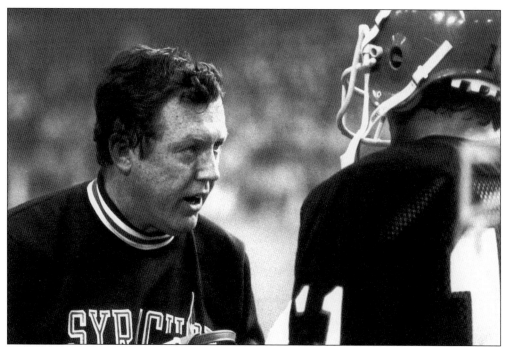

A FRANK DISCUSSION. Frank Maloney, who succeeded the legendary Ben Schwartzwalder before the start of the 1974 season, talks strategy with quarterback Dave Warner. Maloney's teams went 32-46 in seven seasons. The highlight came in 1979, when his team recorded a 7-5 mark and won the Independence Bowl. It was an impressive record, considering that Syracuse was forced to play all of its games on the road while the Carrier Dome was being constructed.

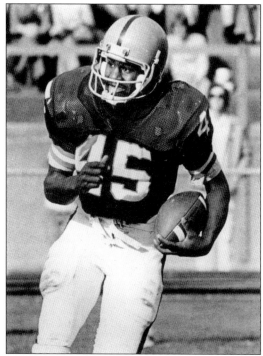

A MONK'S EXISTENCE. Art Monk was the first in a long line of outstanding wide receivers to play for Syracuse. Although he was part of a run-oriented attack, Monk still managed to catch 102 passes for 1,644 yards and nine scores. A first-round pick of the Washington Redskins in 1980, Monk established himself as one of the most prolific receivers in National Football League history. He was a finalist for Pro Football Hall of Fame honors in 2003.

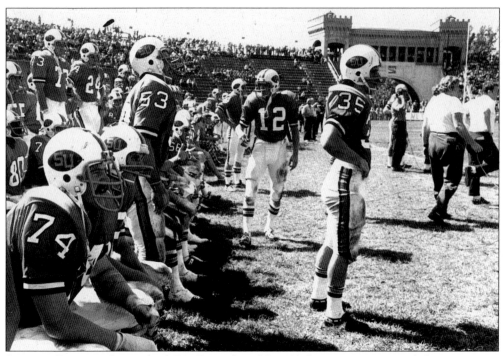

SIDELINE BANTER. Quarterback Jim Donoghue (No. 12) discusses strategy with his teammates during a 1975 game at Archbold Stadium.

ORANGE-AIDERS. Cheri Stankiewicz and Dave Orr cheer on the Orangemen during a 1974 game.

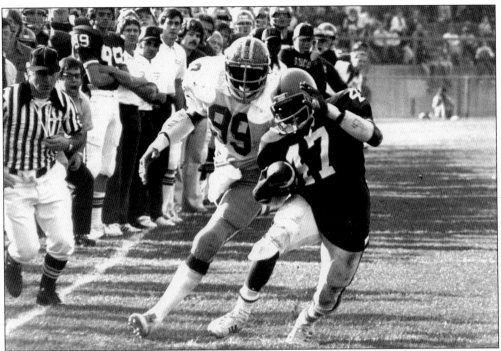

FROSH PHENOM. Joe Morris sprints down the sideline near his bench at Archbold Stadium. It was one of several big gainers for Morris during the 1978 season, as he became the first freshman in school history to rush for more than 1,000 yards.

GETTING HIS KICKS. Dave Jacobs's 58-yard field goal against Boston College during the 1975 season remains the longest in SU history. Jacobs kicked a school-record seven field goals from 50 yards or beyond during his career.

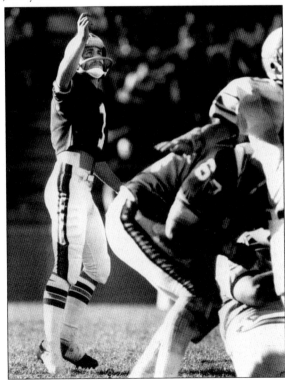

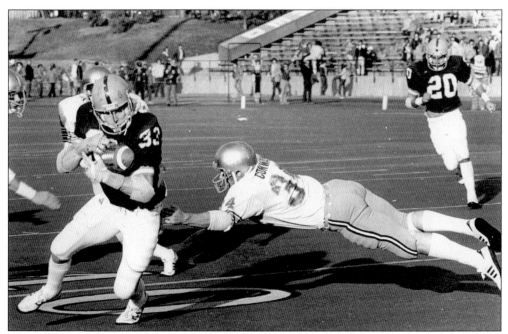

PICK OF THE LITTER. Linebacker Jim Collins, shown here intercepting a pass in a 1979 game against Boston College, is the school's all-time leading tackler with 624. Collins had a school-best 22 tackles that same season against Penn State.

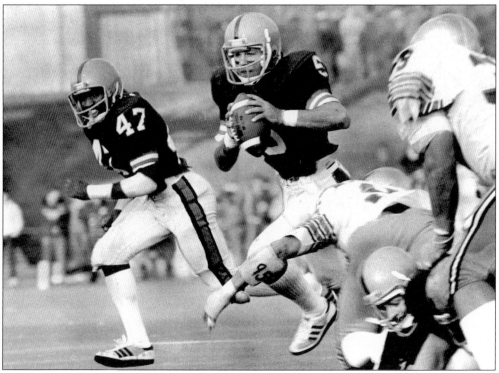

MANY OPTIONS. Paced by the running of Bill Hurley (No. 5) and Joe Morris (No. 47), the Orangemen exceeded 45 points three times during the 1979 season.

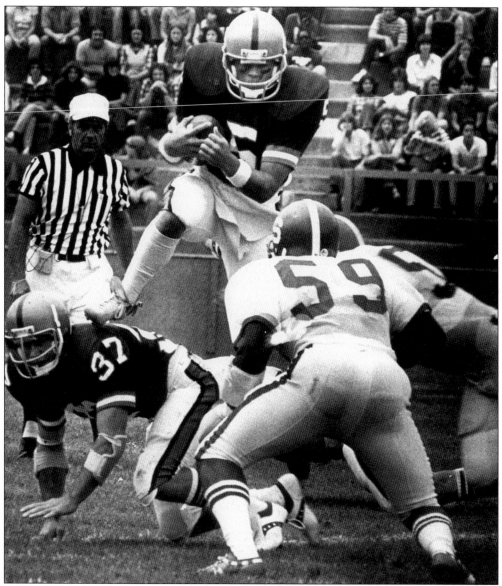

BUFFALO BILL HURLEY. One of the greatest quarterbacks in Syracuse history, Bill Hurley excelled both as a passer and runner. He ranks fifth in passing (3,398 yards), sixth in rushing (2,551 yards), and fourth in total offense (5,949 yards) on SU's all-time lists.

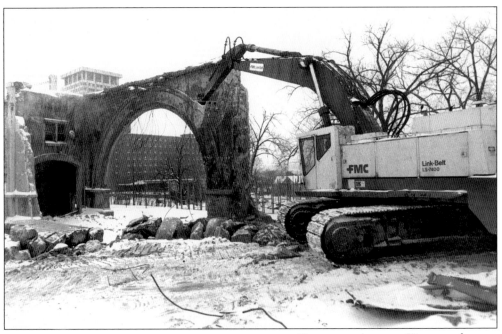

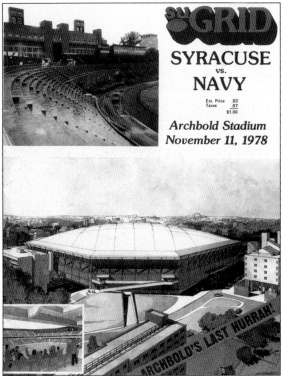

GOODBYE, ARCHIE. Five months after beating Navy 20-17 before 26,429 spectators on November 11, 1978, the demolition began on Archbold Stadium. The Carrier Dome was built on the exact site that Archbold had occupied for 71 years.

Five
DELIRIUM BENEATH THE DOME

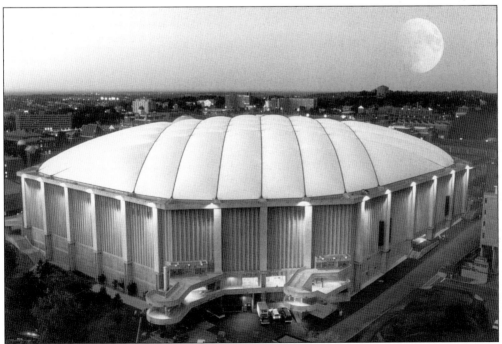

NO PLACE LIKE DOME. Constructed between April 1979 and September 1980, the Carrier Dome has become the most recognizable landmark in central New York. The edifice cost $28 million to build and features an air-supported, Teflon-coated, fiberglass roof.

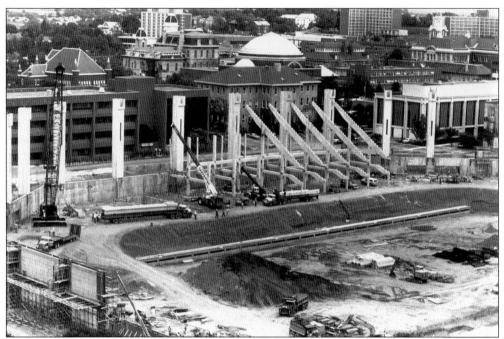

FROM DUST TO DOME. The Carrier Dome was built on the same site occupied by old Archbold Stadium and is constructed primarily of concrete and steel. It seats close to 50,000 spectators for football and more than 30,000 for basketball. Its roof, which was replaced during the summer of 1999, is air-supported by 16 five-foot fans.

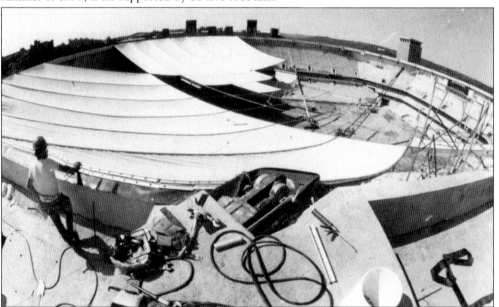

A GRAND OPENING. Syracuse tri-captains Joe Morris (No. 47), Jim Collins (No. 33), and Dave Warner (No. 11) prepare for the coin toss before the first football game ever played in the Carrier Dome, on September 20, 1980. Morris wound up returning a kickoff for a touchdown, as SU defeated Miami of Ohio that night 36-24.

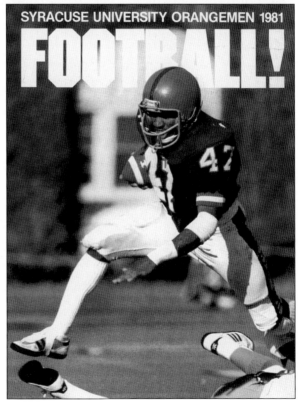

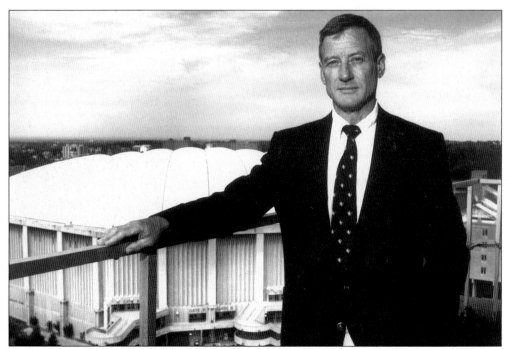

BUILDING BY JAKE. In March 1978, Jake Crouthamel was named the ninth athletic director in school history. The former Dartmouth College football coach oversaw dramatic growth of the school's athletic programs and was a driving force behind the construction of the Carrier Dome.

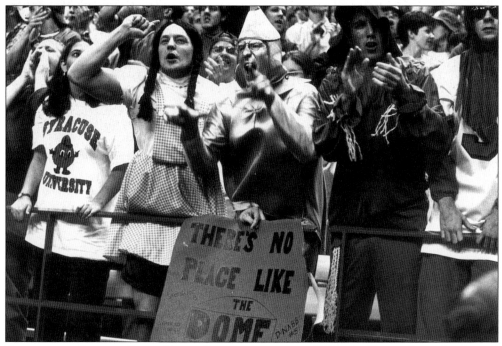

FOLLOW THE ORANGE-BRICK ROAD. Since its opening in 1980, the Carrier Dome has hosted nearly six million football fans, including these Wizard of Oz characters.

82

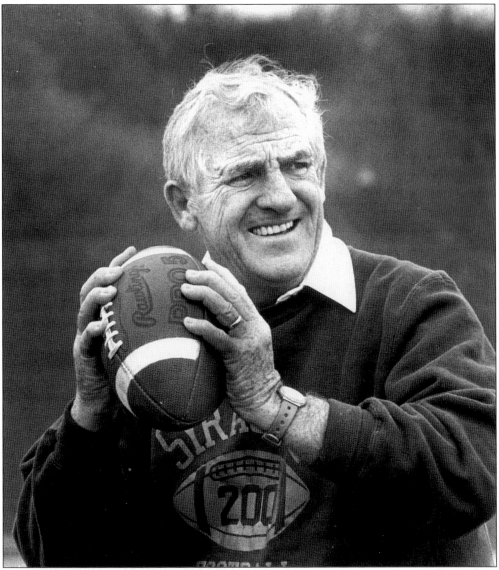

COACH MAC. Upon replacing Frank Maloney after the 1980 season, Dick MacPherson vowed to revitalize the SU football program. Success did not come immediately, but the immensely popular coach eventually made good on his promise, guiding the Orangemen to a 66-46-4 record and five bowl appearances in his 10 seasons.

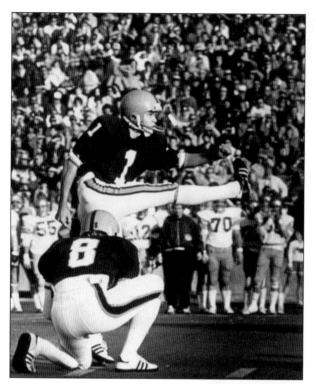

AUTOMATIC ANDERSON. That was kicker Gary Anderson's nickname, and it is easy to understand why. In 1981, his senior year, he converted a school-record 95 percent (18 of 19) of his field goal attempts. It was a harbinger of things to come. In his two decades in the National Football League, Anderson established himself as the league's all-time leading scorer.

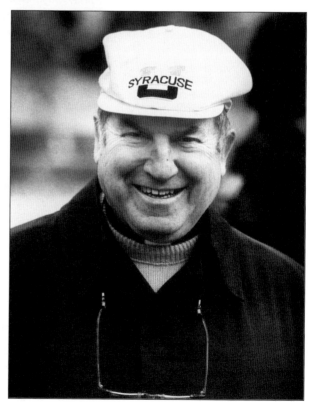

FATHER CHARLES. For nearly three decades, Fr. Charles Borgognoni served as chaplain of the football team.

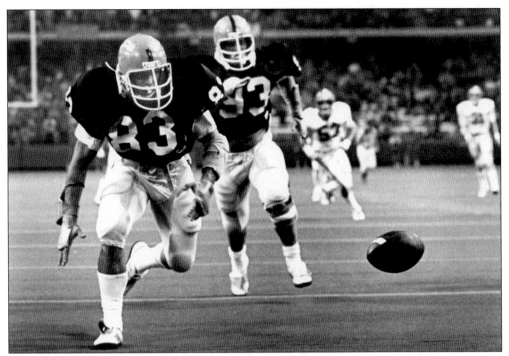

BLOCK PARTY. Defensive end Jamie Kimmel chases after a punt that he blocked during a 17-9 victory against Rutgers University in the Carrier Dome on October 25, 1980.

A GREAT RUN. Joe Morris finished his marvelous career at Syracuse in 1981, with a school-record 4,299 yards rushing. The five-foot seven-inch, 195-pound running back was also a dangerous kick returner. He averaged 25 yards a return during his career and took two kickoffs back for touchdowns.

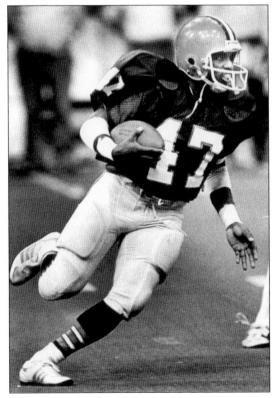

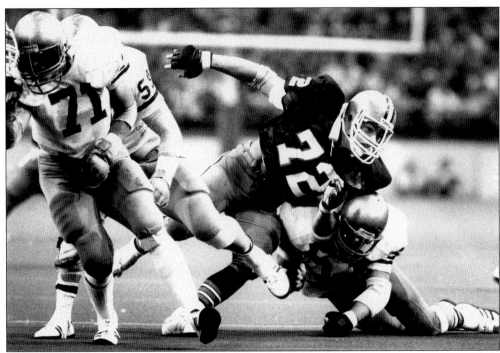

LEADER OF THE SACK. All-American defensive end Tim Green was a relentless pass rusher and tackler. A Rhodes Scholar finalist, Green is the school's all-time sack leader with 45.5 and ranks 11th all-time in tackles with 341.

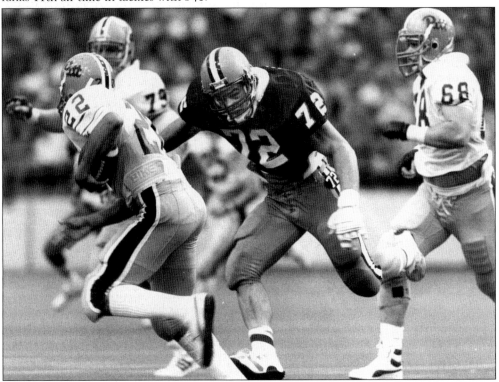

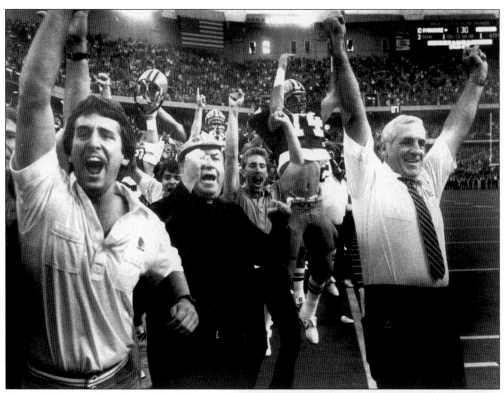

GIANT SLAYERS. On September 29, 1984, Syracuse University scored the biggest upset in its history when it knocked off top-ranked Nebraska 17-9 in front of 47,280 in the Carrier Dome. The Huskers had crushed SU 63-7 the year before in Lincoln, Nebraska, and came to Syracuse as 24-point favorites. The Orangeman, thanks to this leaping 40-yard touchdown reception by Mike Siano (No. 14), were able to stun Nebraska and the college football world. The victory was one of the finest moments for SU coach Dick MacPherson (above, right).

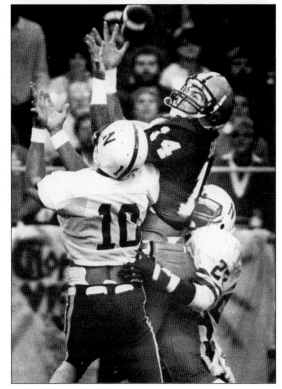

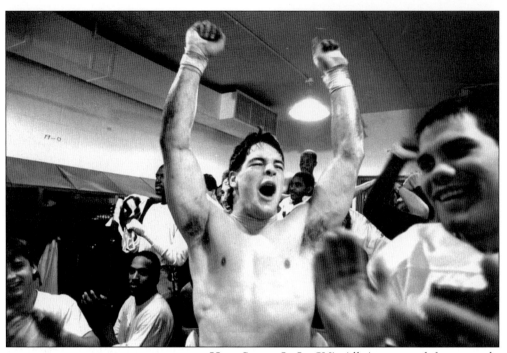

How Sweet It Is. SU's All-American defensive end Tim Green (center) whoops it up in the Carrier Dome locker room after the Orangemen's stunning upset of top-ranked Nebraska on September 29, 1984.

TODD'S FLING WITH FAME. Todd Norley did not leave school as one of the greatest quarterbacks in SU history, but he will forever be remembered for engineering the monumental upset of Nebraska during the 1984 season.

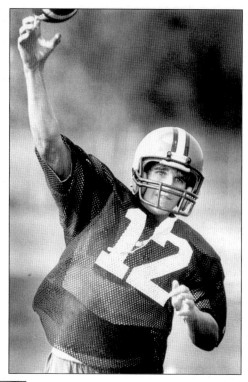

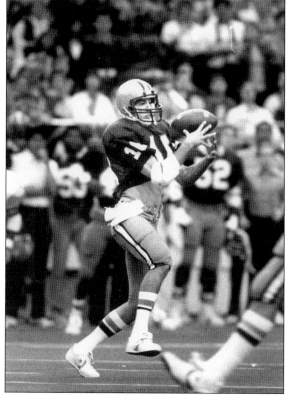

LIKE FATHER, LIKE SON. During the mid-1980s, a quarter century after his father, Gerhard Schwedes, helped SU to its first national championship, Scott Schwedes was starring as a punt returner and wide receiver for the Orangemen. Scott finished his career as the fourth-leading receiver in school history, with 139 catches for 2,111 yards and 16 scores.

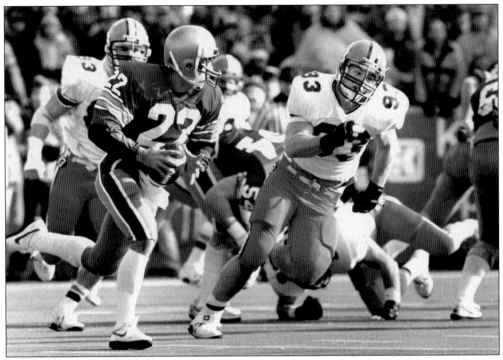

A NOSE FOR THE FOOTBALL. Nose tackle Ted Gregory, shown here bearing down on Boston College quarterback Doug Flutie, earned All-American honors for the Orangemen in 1987.

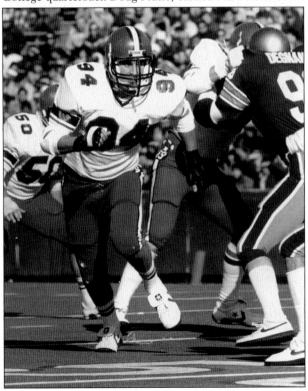

A PERFECT LEADER. Paul Frase, a three-year starter on the defensive line, served as captain of SU's unbeaten 1987 team. He was named to the Orangemen's All-Century team.

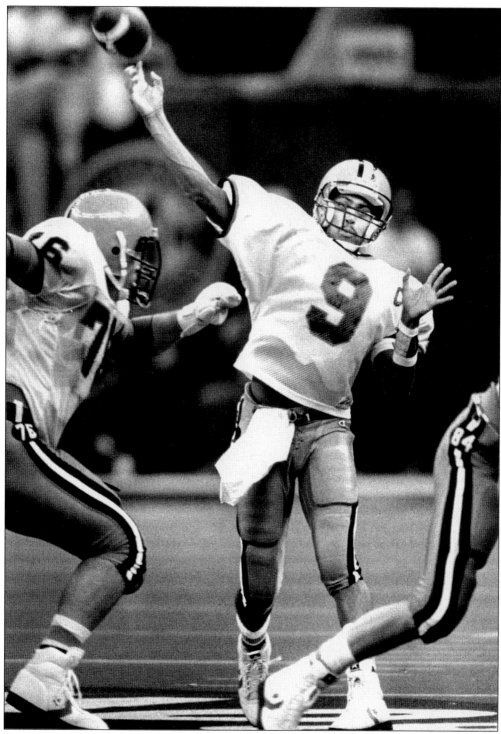

THE DON OF SYRACUSE. Quarterback Don McPherson led the Orangemen to an 11-0-1 record in 1987. A member of Syracuse's All-Century team, McPherson ranks third all-time on the school's passing list, with 5,812 yards and 46 touchdowns.

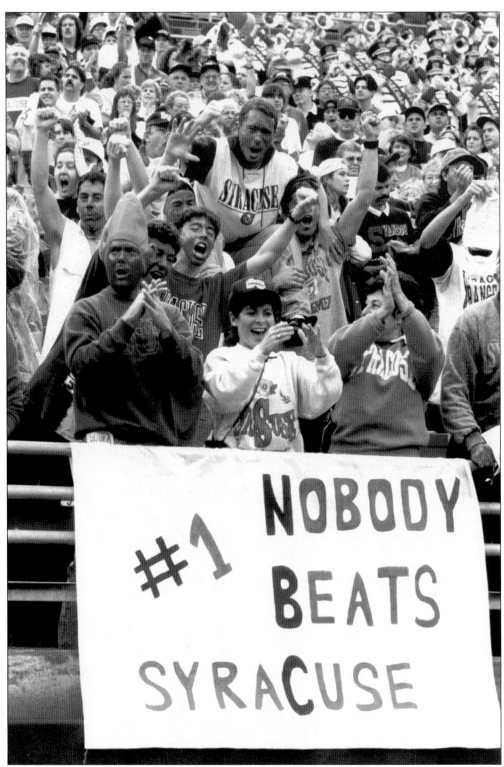
FANDEMONIUM. The sign was dead on in 1987, as Syracuse went 11-0-1.

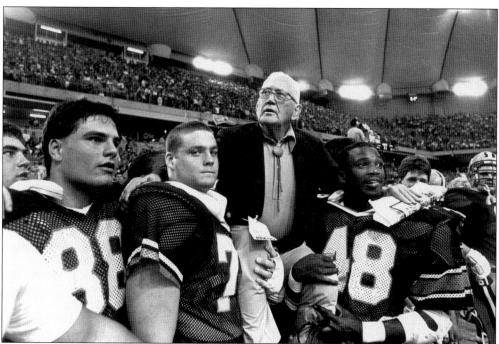

LION TAMERS. Syracuse and Penn State waged a fierce rivalry for eastern football supremacy for 68 years. The rivalry became one sided during the 1970s and early 1980s, with the Nittany Lions reeling off 16 consecutive wins in the series. The Orangemen put a stop to that when they clobbered Penn State 48-21 on October 17, 1987, in the Carrier Dome. Among the 50,011 spectators was former SU coach Ben Schwartzwalder (shown here getting a postgame ride from some of the victorious players). A key performer in the game was wide receiver Tommy Kane (No. 82), who finished the season with a school-record 14 touchdown receptions. The series with Penn State was halted after the 1990 game, with the Lions holding a 40-23-5 edge.

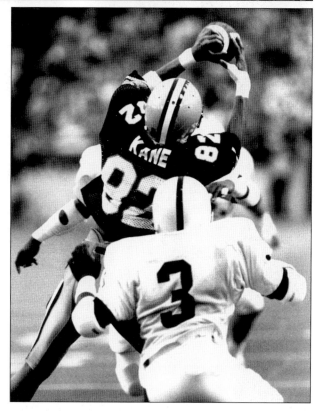

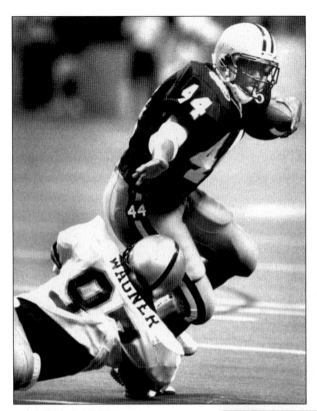

A Perfect Ending. Michael Owens (No. 44) preserved Syracuse's unbeaten season in 1987, when he scored a two-point conversion as time expired to give the Orangemen a 32-31 victory against West Virginia in the regular season finale. Tight end Pat Kelly (No. 84) caught the touchdown pass to set up Owens's conversion run.

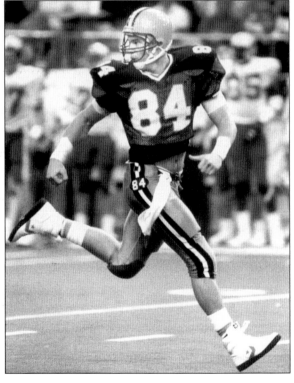

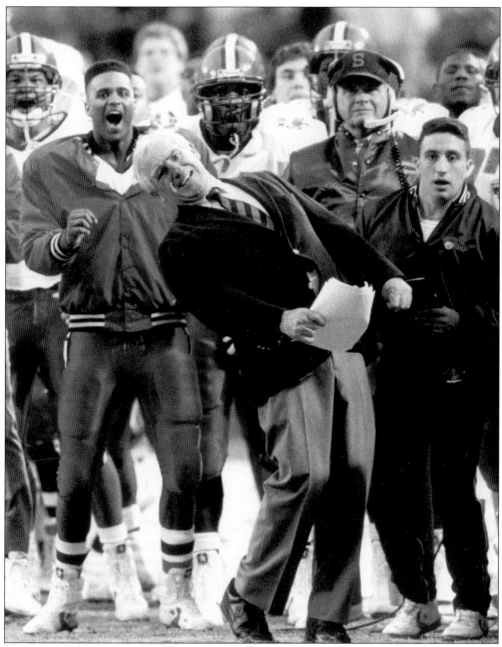
EMOTIONAL MAC. Fiery SU coach Dick MacPherson became so beloved after restoring the Orange football program to national prominence that the Onondaga County Republican party inquired about him running for mayor.

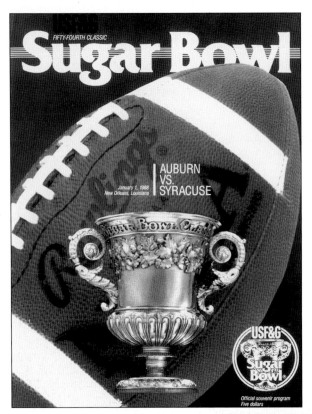

A SOUR FINISH TO THE SUGAR BOWL. The only blemish on Syracuse's 1987 record came in the Sugar Bowl, when Auburn opted to kick a field goal as time expired and settle for a tie. The decision drew the ire of coach Dick MacPherson, who could not believe his counterpart Pat Dye did not go for the win.

HAULING IN THE HARDWARE. Don McPherson won numerous honors for his performance during the 1987 season. He was named a consensus first team All-American and received the Johnny Unitas Award as the nation's top quarterback. He also finished second in the Heisman Trophy voting. Many believed McPherson should have beaten out Notre Dame's Tim Brown as the nation's top player that season.

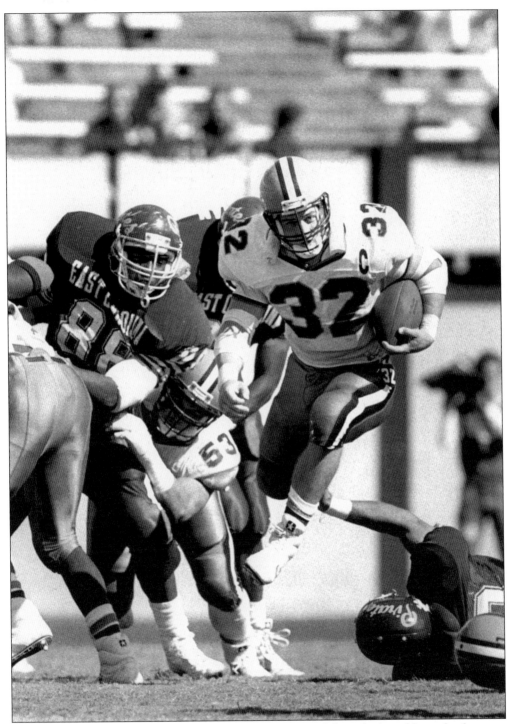

MOOSE ON THE LOOSE. Fullback Daryl "Moose" Johnston followed admirably in the footsteps of bruising predecessors Larry Csonka and Jim Nance. A punishing runner and blocker, Johnston was named to SU's All-Century team and went on to have a stellar career as the lead blocker for Emmitt Smith, the National Football League's all-time leading rusher.

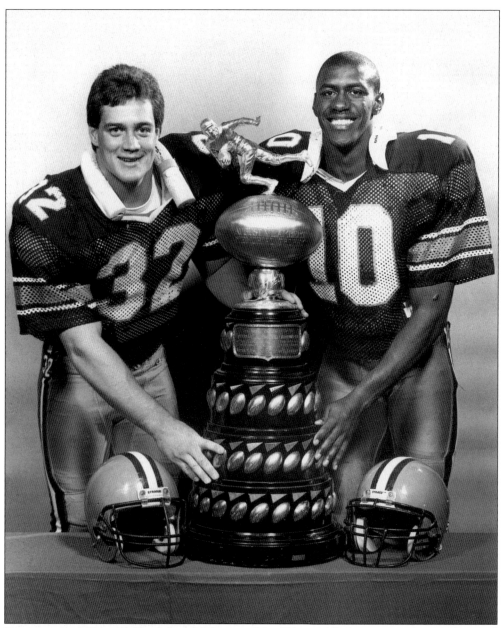

BEASTS OF THE EAST. Fullback Daryl Johnston (No. 32) and All-American safety Markus Paul pose with the 1987 Lambert Trophy, presented annually to the top football team in the East. Johnston, a bruising blocker and runner, and Paul, the school's all-time interception leader, were key contributors to SU's 11-0-1 record that season.

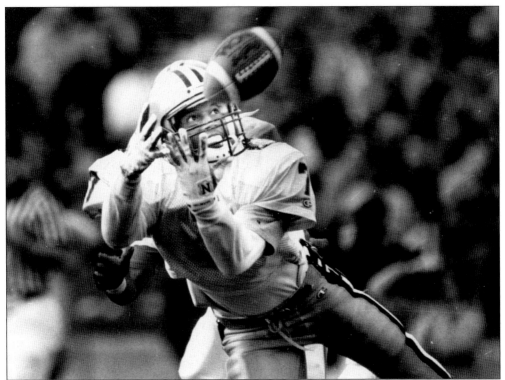

EYE ON THE BALL. Despite playing only two seasons, Rob Carpenter ranks as SU's fifth all-time leading receiver, with 93 receptions for 1,656 yards and 10 touchdowns.

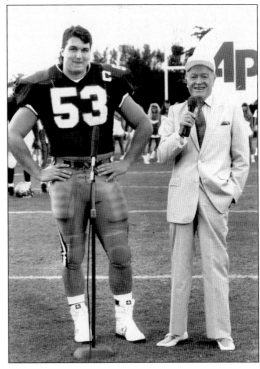

COMIC RELIEF. SU All-American center John Flannery is roasted by comedian Bob Hope during the taping of a 1990 college football special.

COMING TO THEIR DEFENSE. Defensive lineman Rob Burnett served as team captain in 1989 and was named to SU's All-Century team. He led the Orangemen in sacks with 11 in 1987.

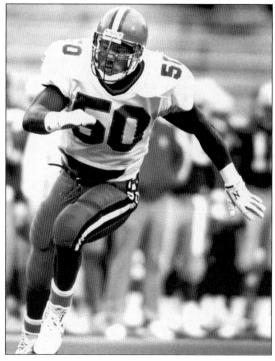

SACKMEISTER. Kevin Mitchell ranks fourth all-time in sacks with 21. He led the Orangemen in that category in 1991 and 1992.

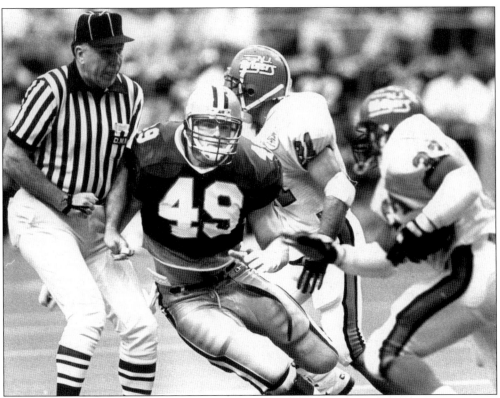

A STUDY IN PERSEVERANCE. Despite undergoing nearly a dozen surgeries on his knees, linebacker Dan Conley ranks 11th on SU's all-time tackle list.

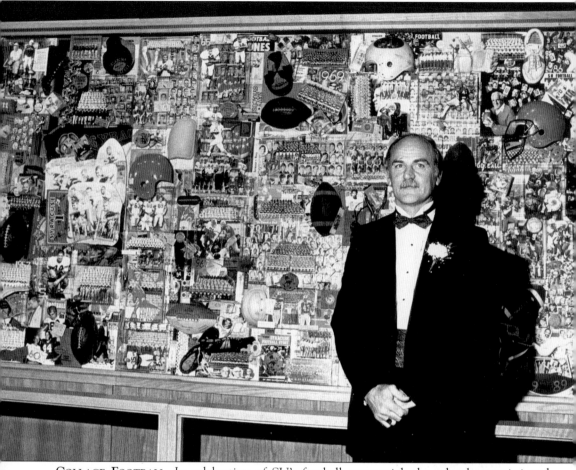

COLLAGE FOOTBALL. In celebration of SU's football centennial, the school commissioned renowned alumnus Jim Ridlon to produce this collage.

OTTO THE ORANGE. The fruity mascot has been entertaining Carrier Dome spectators for nearly two decades.

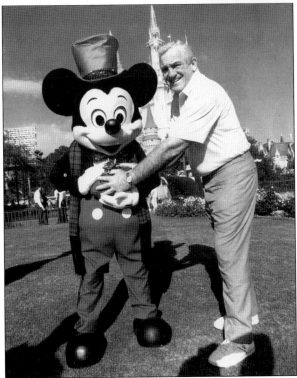

MAC AND MICKEY. Coach Dick MacPherson takes time out from preparations for the 1989 Hall of Fame Bowl to clown around with Mickey Mouse at Disney World.

THE PRIDE OF THE ORANGE. Syracuse University's marching band belts out the school fight

song after a touchdown during a 1994 game in the Carrier Dome.

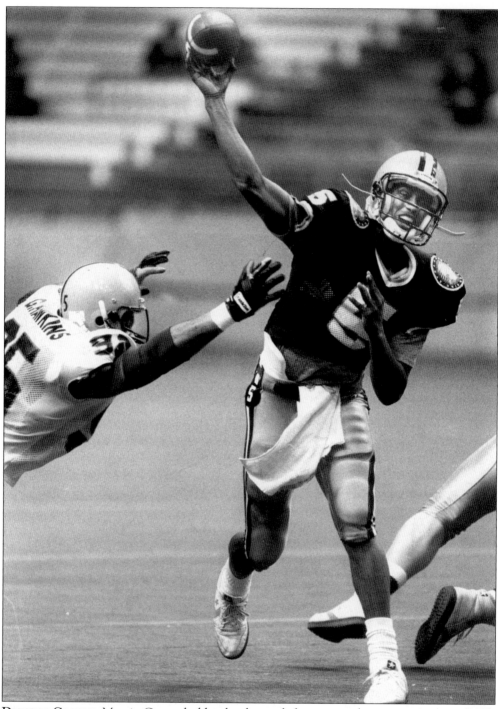

DIGGING GRAVES. Marvin Graves holds school records for most yards passing in a game (425), a season (2,547), and a career (8,466).

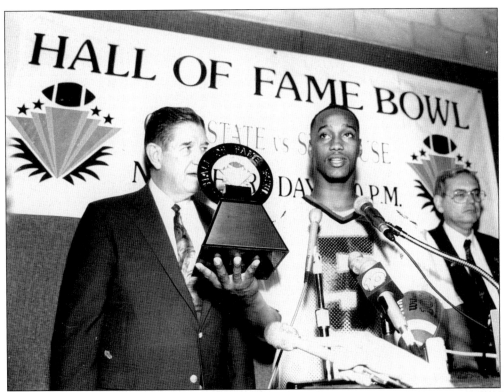

MVP. Marvin Graves (No. 5) earned MVP honors in the 1990 Aloha Bowl, the 1992 Hall of Fame Bowl, and the 1993 Fiesta Bowl.

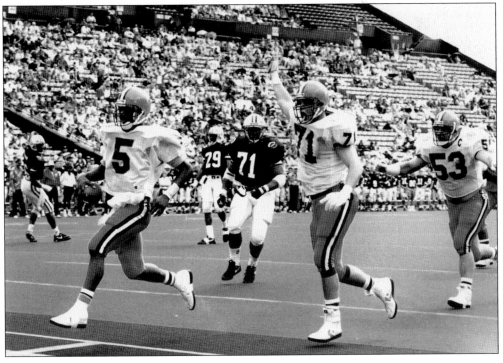

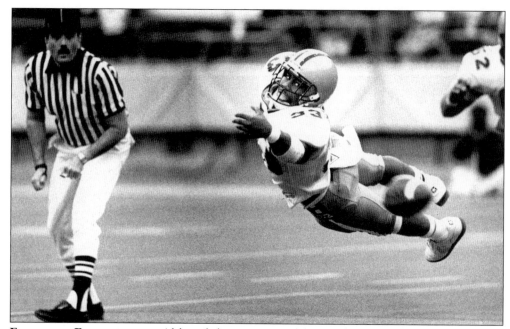

EXCEEDING EXPECTATIONS. Although he was not widely recruited, David Walker wound up making a lasting impression at SU. He led the team in rushing from 1990 to 1992 and ranks as the school's fifth all-time leading rusher with 2,643 yards. Walker has been an assistant coach at his alma mater since 1995.

PROGRAMMED FOR SUCCESS. Marvin Graves passed for 309 yards and two touchdowns as Syracuse defeated Ohio State 24-17 at the Hall of Fame Bowl in Tampa, Florida, on January 1, 1992.

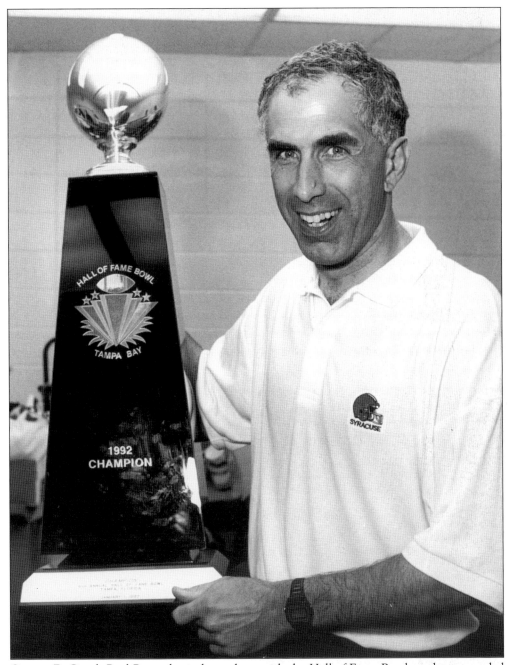

COACH P. Coach Paul Pasqualoni, shown here with the Hall of Fame Bowl trophy, succeeded Dick MacPherson before the 1991 season and strung together 10 consecutive winning seasons.

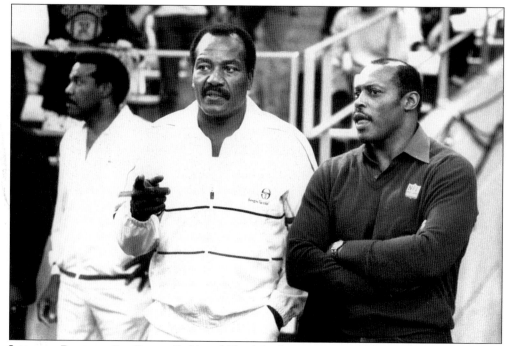

LEGENDS RETURN. Jim Brown (left) and Floyd Little converse on the Carrier Dome sidelines before a game in the late 1980s.

MISSILE LAUNCH. Qadry Ismail earned All-American honors as a kick returner in 1991. The player known as "the Missile" was also a dangerous wide receiver, as evidenced by his 18.1-yard-per-catch average and five touchdown receptions.

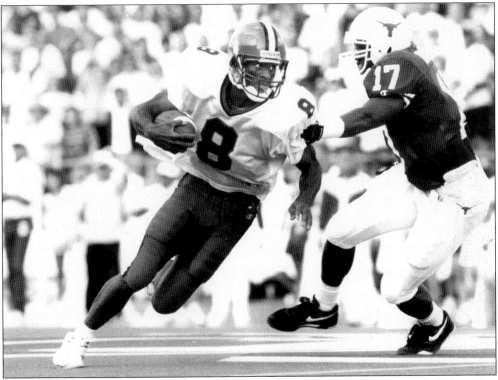

TURNING THE CORNER. Marvin Harrison is SU's all-time leading receiver, with 135 catches for 2,728 yards and 20 touchdowns. A first-round pick of the Indianapolis Colts, Harrison set a National Football League single-season record for most receptions in 2002.

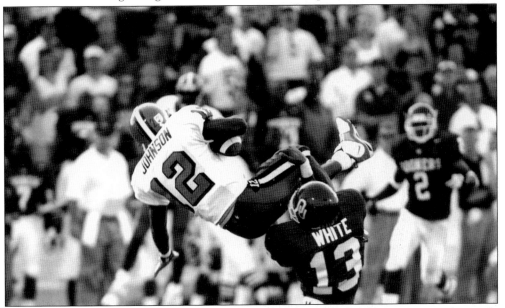

KJ WAS A-OK. Kevin Johnson came to school as a quarterback but was converted to wide receiver. The switch served him well, as Johnson finished his SU career as the eighth-leading receiver in school history, with 98 catches for 1,584 yards and 13 scores.

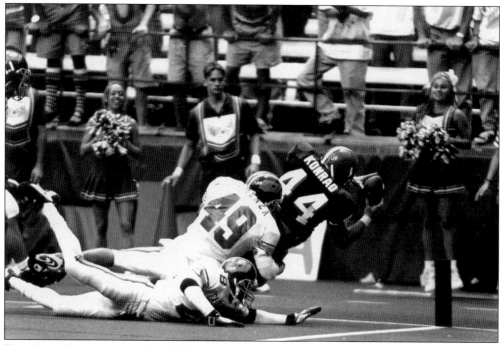

THIS DIVE IS A PERFECT SIX. Fullback Rob Konrad dives into the end zone for a touchdown during a 1995 game. Konrad's average of 5.14 yards per carry is the eighth best in school history.

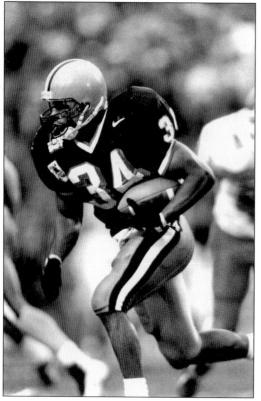

BUCKING THE ODDS. Tebucky Jones converted from running back to cornerback following his junior year and made a remarkably swift and smooth transition. Jones was the first pick of the New England Patriots in 1998.

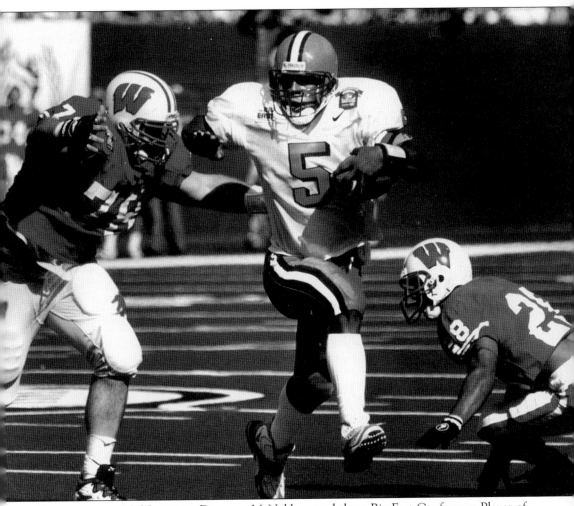

DONOVAN THE MCNIFICENT. Donovan McNabb earned three Big East Conference Player of the Year awards and tossed a school-record 77 touchdown passes during his four years as SU's starting quarterback.

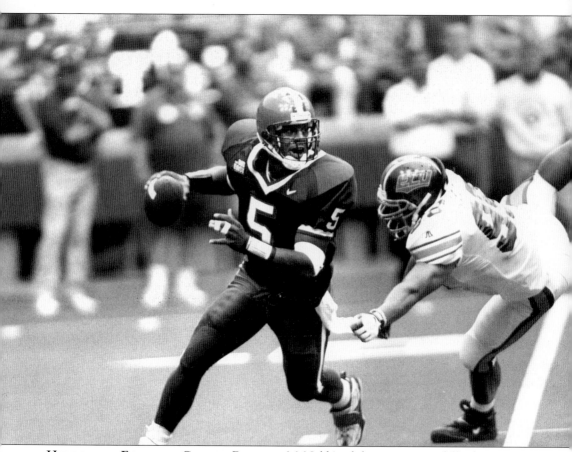

HOUDINI IN FOOTBALL CLEATS. Donovan McNabb's ability to escape difficult situations brought defenders to their knees and spectators to their feet.

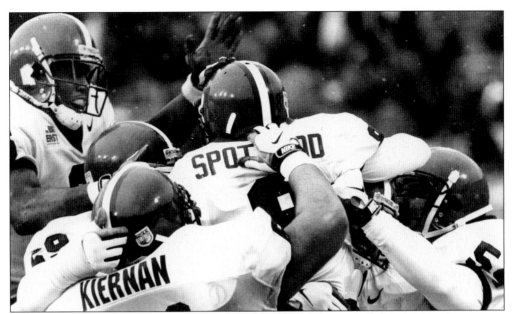

GOOD RETURNS ON THIS INVESTMENT. Quinton Spotwood, shown here celebrating after scoring one of his eight touchdowns during the 1997 season, finished his career as the sixth-leading receiver in school history, with 115 catches for 1,653 yards and 15 touchdowns. Spotwood was also a dangerous punt returner. He established a school record in 1997, when he returned four punts for touchdowns.

CLUTCH CATCH. Tight end Stephen Brominski does not show up on any of the school's all-time receiving lists, but he will always be remembered for catching a touchdown pass from Donovan McNabb as time expired to give SU a 28-26 victory against Virginia Tech on November 14, 1998.

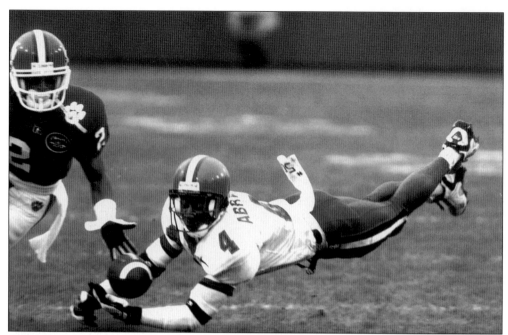

A Pick-Me-Up. Kevin Abrams, a member of SU's All-Century team, goes all out to pick off this pass during the 1996 Gator Bowl in Jacksonville, Florida. Abrams had two interceptions that day, as the Orangemen trounced Clemson 41-0. Abrams earned All-American honors at cornerback in 1995 and 1996.

This Donovin Could Play, Too. Strong safety Donovin Darius picked off seven passes in 1997 to earn All-American honors.

DOME-FIELD ADVANTAGE. Since opening in 1980, nearly six million fans have cheered on the SU football team. The "12th man" has helped the Orangemen compile an 82-35-2 record there.

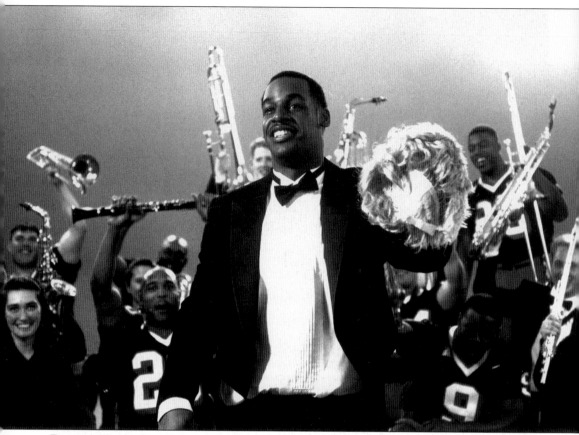

BANDED TOGETHER. As part of a promotional campaign to sell tickets to SU football games, quarterback Donovan McNabb donned a tuxedo and a wig and conducted his teammates in a television commercial.

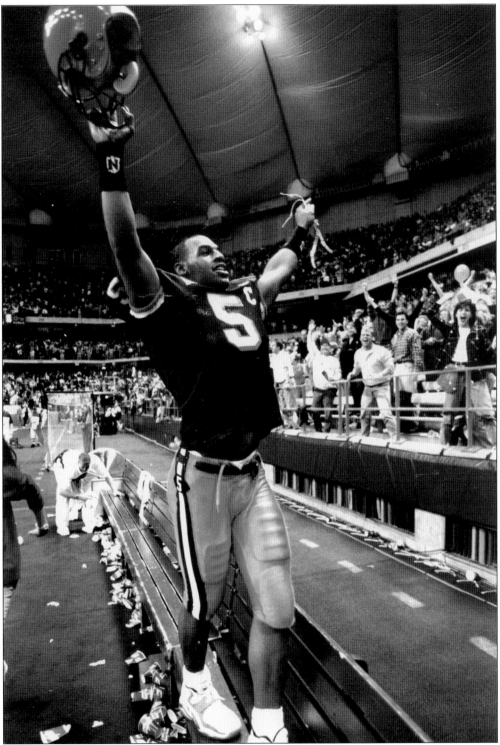

A FOND FAREWELL. Quarterback Donovan McNabb bid his legion of fans adieu on November 28, 1998, with a 66-13 demolition of Big East rival Miami in the Carrier Dome.

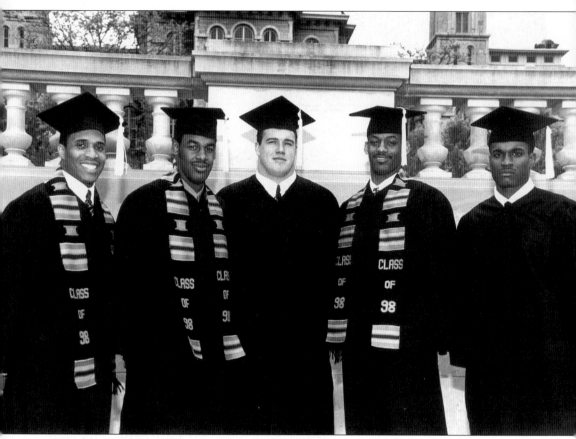

POMP AND CIRCUMSTANCE. In 2000, the Syracuse University football team won the American Football Coaches Association Academic Achievement Award for having a 100 percent graduation rate. Pictured are, from left to right, Kevin Johnson, Donovan McNabb, Marc Pilon, Jason Poles, and Darryl Daniel.

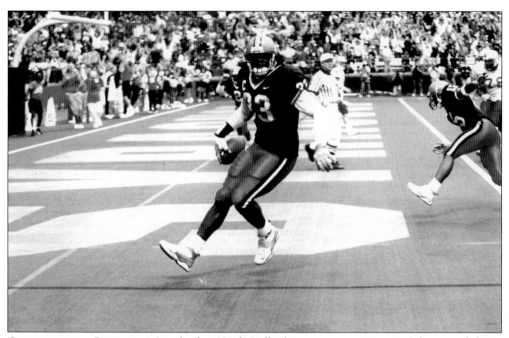

GOING ON THE OFFENSIVE. Linebacker Keith Bulluck returns an interception for a touchdown in a 24-23 loss to Boston College on October 30, 1999, in the Carrier Dome. Bulluck was named team MVP that season. He is the seventh-leading tackler in school history.

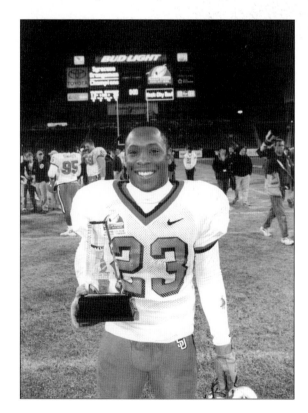

CARRYING ON THE TRADITION. James Mungro rushed for 1,170 yards and 14 touchdowns his senior season (2001) as Syracuse finished 10-3 and defeated Kansas State in the Insight.com Bowl. Mungro finished his career with 2,869 yards rushing, placing him third all-time behind leader Joe Morris and runner-up Larry Csonka.

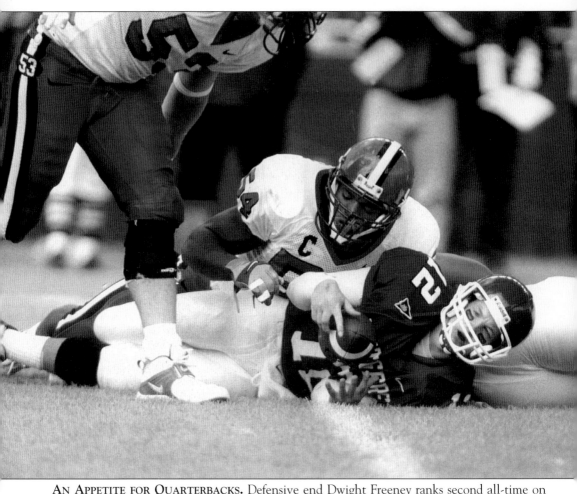

AN APPETITE FOR QUARTERBACKS. Defensive end Dwight Freeney ranks second all-time on the SU quarterback sack list with 34.

CHASING A RECORD. Dwight Freeney set a school and National College Athletic Association record for most quarterback sacks in a season, with 17.5 in 2001.

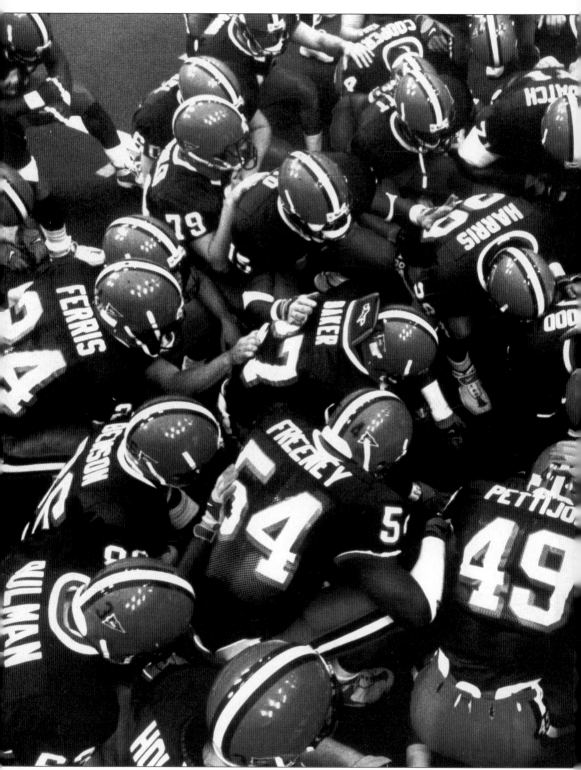

HUDDLE-UP. The Orangemen huddle together before their 2001 home opener.

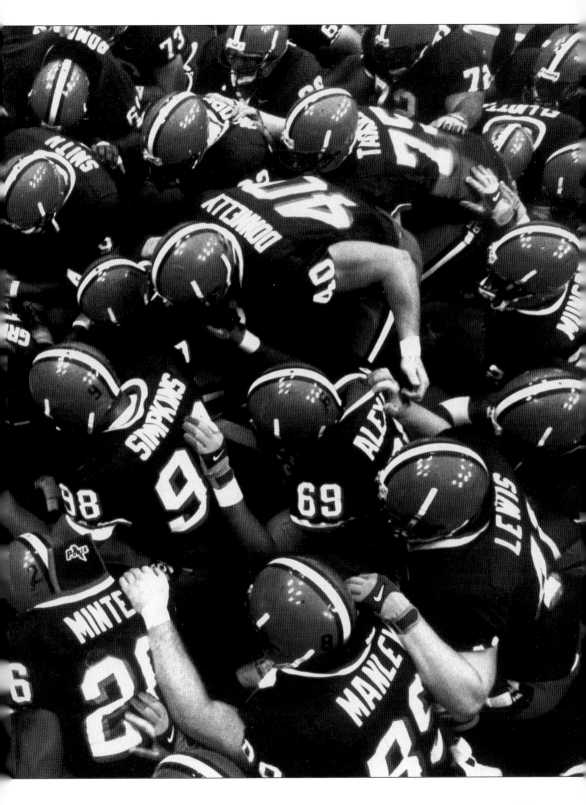

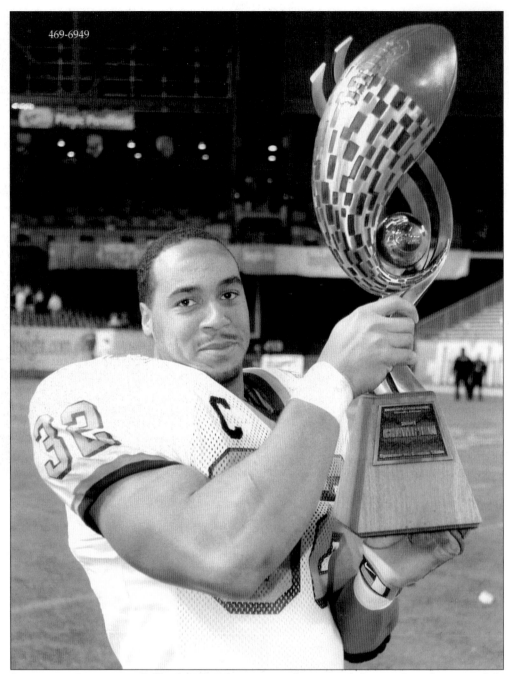

STAGING A COMEBACK. Fullback Kyle Johnson starred in several theatrical productions while attending Syracuse. His finest performance may have been his comeback from a serious knee injury that sidelined him for all but one game of the 2000 season. Johnson returned in 2001 and helped the Orangemen to a 10-3 record and a victory over Kansas State in the Insight.com Bowl.

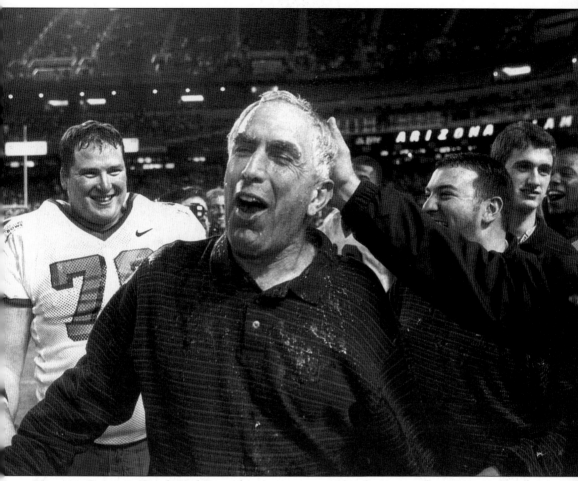

VICTORY SHOWER. Coach Paul Pasqualoni receives a surprise dousing in the waning moments of SU's Insight.com Bowl victory against Kansas in 2001. Pasqualoni is the second winningest coach in Syracuse history.

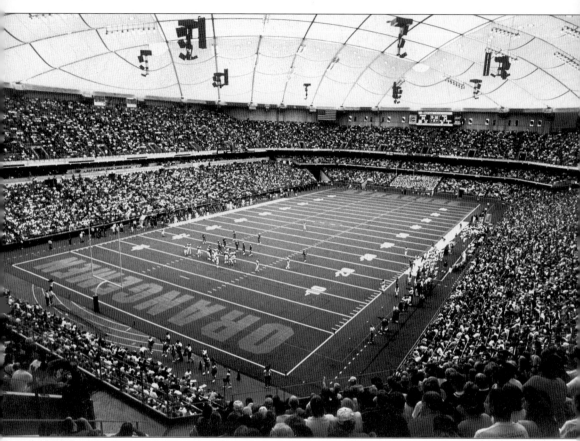

THE CUSE IS IN THE HOUSE. The Orangemen have had only two losing home records in the 23 seasons they played football in the Carrier Dome.